# The garden of
# CLAUDE
# MONET

The four seasons of Giverny
photographed by Charles Prost

BARRON'S

**Graphic design:** Jean-François Lejeune

**Giverny map:** Françoise Vandermeerschen (thanks to Brigitte Tack)

We thank

Gérald Van der Kemp, member of the Institute, curator of the Claude Monet
Foundation, who has made Giverny accessible to us.

Claudette Lindsey, general secretary of the Claude Monet Foundation,
whose kindness and consideration made our task much easier.

Gilbert Vahé, chief gardener, thanks to whom every morning Monet's gardens
come back to life, and who was always welcoming.

All the members of the Giverny staff, who were most pleasant and accommodating.

**Photograph Credits**

Collection Musée Marmottan, Paris: pp. 8, 10, 12, 16, 17, 18, 21

Collection Philippe Piguet, Paris: pp. 11, 23

Collection Roger Viollet, Paris: p. 14

Collection Country Life Magazine, London: pp. 15, 19

First edition for the United States and Canada published by Barron's Educational Series, Inc. 1995

© Copyright 1995 by Barron's Educational Series, Inc., in respect to the English language translation.

© Copyright 1993 by Casterman, Tornai, for the original version.

All inquiries should be addressed to: Barron's Educational Series, Inc., 250 Wireless Boulevard, Hauppauge, New York 11788

Library of Congress Catalog Card No.: 95-5289

International Standard Book No. 0-8120-6512-3

**Library of Congress Cataloging-in-Publication Data**

Prost, Charles.
    [Jardin de Claude Monet.    English]
    The garden of Claude Monet : the four seasons of Giverny /
photographed by Charles Prost.
        p.   cm.
    ISBN 0-8120-6512-3
    1. Gardens—France—Giverny.    2. Monet, Claude, 1840–1926—Homes
and haunts—France—Giverny.    I. Title.
SB466.F83G58613    1995
712'.6'094424—dc20                                                                              95-5289
                                                                                                          CIP

Printed in Spain
5678   7150   987654321

*For Lucie (Picard),*
*who worked wonders with colored pencils,*
*who loves french fries, pasta,*
*ravioli, gnocchi, pizza,*
*new clothes, new shoes,*
*flowers, painting, and Charles.*

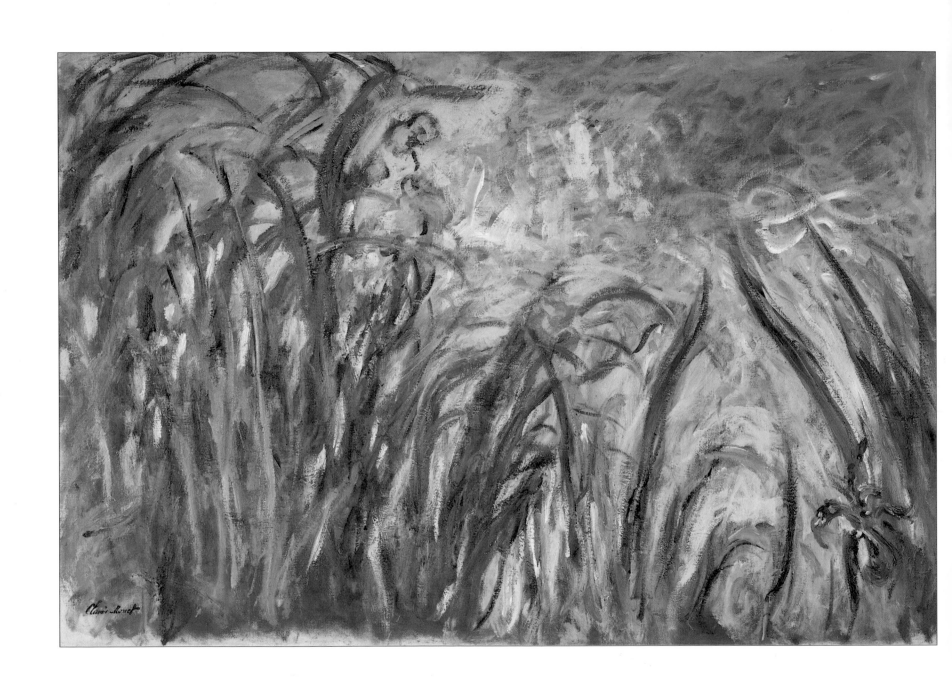

Irises, *1915-1922, oil painting on canvas*
*Collection of the Marmottan Museum, Paris*

In the late nineteenth century, Ernest Hoschedé was one of the most important fabric merchants in Paris. He was very rich, even more so because his wife Alice had brought him a dowry of a hundred thousand francs and, after her father's death, the castle of Rottembourg in Montgeron, a few miles south of Paris.

Ernest Hoschedé was passionately interested in paintings. He opened his château to artists and bought and collected their paintings. His excellent taste inspired him to select the best. In 1877, Monet spent several months in Montgeron. There, he created four works for the decoration of the Grand Salon, each of which was 6 to 9 square feet (2–3 sq. m), an unusual size for Monet at that time.

But Ernest Hoschedé, although a remarkable collector, was a rather mediocre businessman. In truth, fabrics and business did not interest him at all. However, his taste in art was ahead of its time. He sold his Courbets, Millets, and Corots and replaced them with works by contemporary painters. He acquired some Boudins, Manets, Sisleys, Degas, and Renoirs. The more his collection prospered, the more he neglected his work. Business was so bad that he went bankrupt on August 24, 1877, which did not prevent him from buying even more Monets. However, soon afterward, the château had to be sold. He was totally ruined.

In 1879, Hoschedé, his wife Alice, and their six children, plus a cook and a tutor went to live with Monet at his home in Vétheuil. Including Monet, his wife Camille (who died September 5, 1879), and their two children, a total of 14 people lived under the same roof. It became imperative to move. Monet went to live in a larger house in Poissy, a town he did not like very much. Hoschedé started to go to Brussels or Paris more and more often. So much so that the relations between Monet and Alice became intimate. Monet decided to leave Poissy, which he hated. He got on a local freight train to explore the area and find a place where he would enjoy living. From the train doorway, he discovered Giverny. There, he found a very large pink house with a lot of land that was for

> *"I feel despondent away from Giverny. Everything must be so beautiful with such incredible weather."*
>
> CLAUDE MONET TO ALICE, FROM ROUEN, APRIL 1892

— 9 —

rent, and he took it. He moved in May 1883, thanks to the financial help of his dealer, Durand-Ruel, and settled in Giverny with Alice and his and her children.

Monet sold more and more paintings for increasingly larger sums of money. In November 1890, he bought the house and the land at Giverny.

Then Monet became a gardener.

Monet always had a passion for gardens. He claimed that outside of painting and gardening, he was worthless. In all his homes, in Ville-d'Avray, Louveciennes, Argenteuil, Vétheuil, he grew flowers; and from these beds of flowers he created paintings.

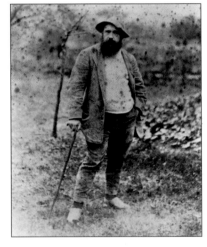

In Giverny, the landscaping was of a greater magnitude. The land was over 2 acres. A very large spade was needed! Monet laid out some plans, knocked down trees, erected metal vertical and arched supports for climbing roses, and built three greenhouses. He hired a head gardener and assigned five assistants. He sought advice from Georges Truffaut, an expert in seeds and bulbs and at that time the best horticulturist in the world.

When one visits Giverny in winter with the rectilinear flower beds and straight paths intersecting at right angles, one could imagine oneself in a classical French garden. With the arrival of spring and the profusion of long-stemmed flowers, the layout and the overview (required for the Vaux-le-Vicomte or Versailles gardens in order to discover Le Nôtre landscaping) do not allow for full appreciation of the gardens. Monet's garden cannot be grasped in a single glance. One has to walk through it. A stroll reveals a succession of colored harmonies. One wanders among colors and these colors are the flowers.

Monet's garden is like a palette, using different materials and dimensions to achieve its effect. In sowing and in planting, Monet remained a painter: he planned the blooming harmonies. But to foil the gardener's scientific calculations, the uncertainties of the weather might cause earlier or later blooming. The colors were anticipated, but the blossoming could be full of surprises. As for any creation, chance also played a major role.

Monet is the only Western painter to have designed his garden, to have worked at it like a masterpiece. When one visits Rubens's house and garden in Anvers, one wonders whether he had similar visions—but this is mere speculation.

*Monet in 1889, a few years after his arrival in Giverny*
*Photograph by Theodore Robinson*

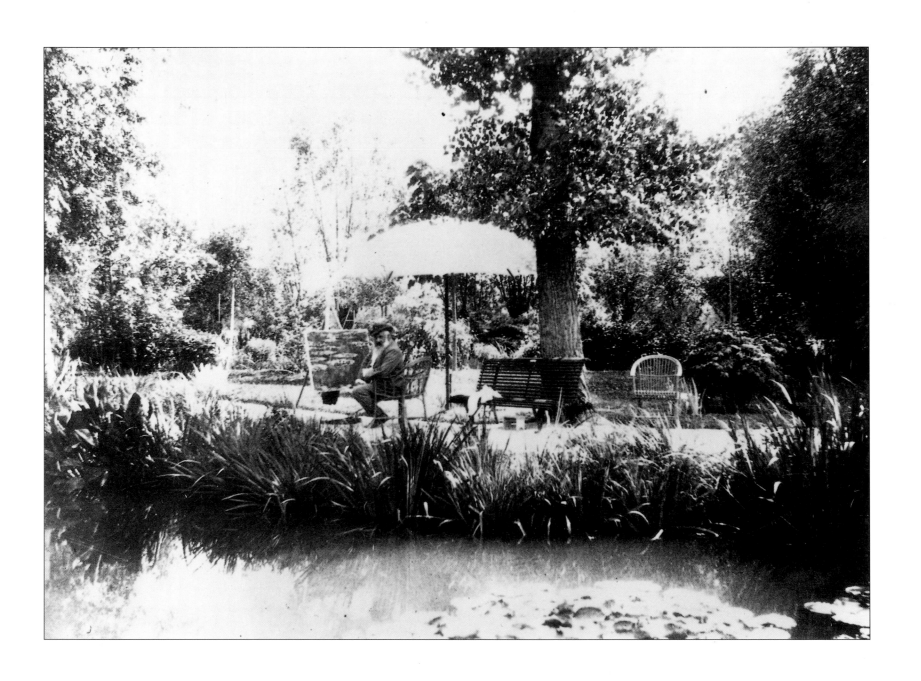

*Monet "About the motif," circa 1920*

*Philippe Piguet photo collection*

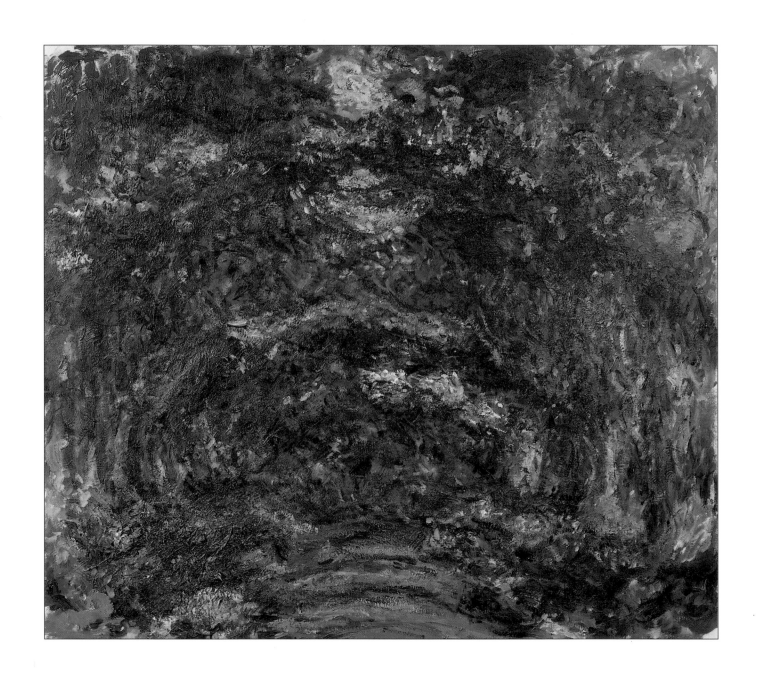

The Path with the Rose Trellises, *circa 1922, oil on canvas*

*Marmottan Museum Collection, Paris*

Monet painted his garden several times but he did not create a garden in order to paint it; he created it to create a garden. He used in his creation another means of expression, which is not that of a painter, yet owes much to his painting talents.

Marcel Proust was the best analyst of artistic creation in France at that time, one who knew how best to describe works of art in their appearance, spirit, and origin, with the singularity that his criticism applies to imaginary artists and works: Bergotte's writings, Vinteuil's sonata, Eltsir's paintings. Marcel Proust, who had never seen Monet's gardens, offered a rigorous analysis:

"If one day I can see Claude Monet's gardens, I feel that I will see, in a garden of nuances and colors, more than flowers; I will see a garden which seems to be less a traditional floral garden and more of a colorist's garden, for example some flowers arranged in an ensemble that is not quite like nature, since they have been planted in such a way that those which blossom at the same time have nuances that harmonize in a blue or pink range; and that the artist's intention, so powerfully manifested, has dematerialized, in some way, all that is not color. Earth flowers and also water flowers, these delicate water lilies that the master has depicted in sublime paintings of which this garden (a true transposition of art, more than a model for paintings, a painting already executed within nature which is illuminated under the eye of a great artist) is like a first and living sketch. At least the delightful palette is already made, and the harmonious tones are prepared . . ."
(*Les Eblouissements* by the Countess de Noailles, Figaro, June 15, 1902)

Another novelist, Louis Aragon, also a lover of painting, introduced the gardens of Giverny into his work:

"When she stood before the beautiful garden that the path divided, she stopped and looked to the left, at the bridge, the water, the light trees, the tender buds, the water plants. Then she turned toward the house where lived the tall elderly man whom she had often seen from a distance, and of whom the whole village spoke. The one who could not see the withered flowers. She saw the blue flowers. At their feet, the earth freshly turned. Blue flowers everywhere. The small path leading to the house. The sun-dappled grass. And more blue flowers . . .

"The light was so beautiful on the flowers . . . What were these flowers? It was believed that there are no truly blue flowers. However . . . Who knows if he saw them blue, the tall old man? His eyes were weak, it seemed. He could become blind. A terrible thought. A man whose whole life was in his eyes. He was over

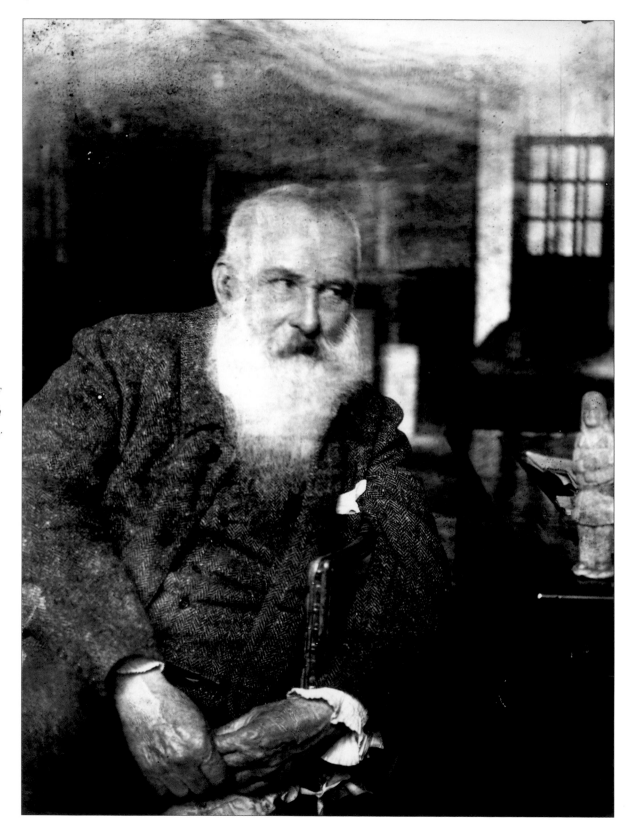

*Monet in June 1926, a few*
*months before his death*
*Photograph by Nicolas Muray*

80 years old. If he became blind . . . One could imagine him demanding that the flowers be pulled out before they withered, those flowers which he would no longer see anyway . . . The blue flowers would give way to roses. Then there would be some white flowers. Each time, in a flash, it was as if one repainted the garden." (Aragon, *Aurélien*, Chapter LXIII)

Claude Monet took great pleasure in his garden in Giverny. Painting often exhausted him; he would rest in his garden. He sometimes painted it as a matter of course. It was not a major but an accessory theme.

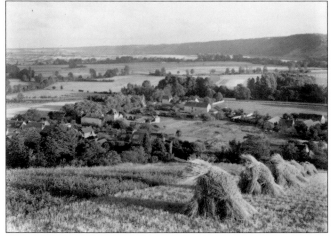

He worked successively on the Riviera, on the coast of Normandy, in Giverny and the surrounding area, in Étretat, in Holland, in Belle-Ile-en-Mer, in Antibes, in the Creuse Valley. During the winter of 1890, he began the series of "Haystacks" (he painted 25 of them). In 1892, he began his series of "Poplars." In February 1892, he started in Rouen the series of the "Cathedrals," which he continued through February, March, and April of 1893.

With Renoir, at la Grenouillère located in Argenteuil, Monet painted the water, the boats and their reflections on the water, and the sun above and below the waters. *Impression Sunrise (Impression, soleil levant)* from which the glorious name of Impressionists would derive, is a painting of water where masts, sky, and sun reflect through the mist on the harbor of Le Havre. Taking up the whole canvas is a simple building, which he had never painted before his "Rouen Cathedral" series, and which he would not paint afterward. More than a manifestation of gothic style, the facade of the cathedral of Rouen is an austere mass like a rock. Monet measured himself against it and he pushed himself to the limit until exhausted. "But I feel weariness overcoming me. I am worn out, and that proves I have said what I had to say." (March 9, 1893). "This cathedral is admirable but it is terribly arid and hard to do, and it will be a delight for me, after that, to paint outdoors." (March 15). "I am broken. Never have I been so tired, physically and men-

*View of Giverny around 1933. One can see the Seine in the background and Monet's house at the center of the picture.*

tally. I am numbed and want nothing more than to lie in bed." (April 2). "I have had a night filled with nightmares, something that never happens to me: The cathedral was falling on me; it seemed to be blue or pink or yellow." (April 3).

During his encounter with the cathedral, Monet experienced an immense desire for nature and water. It was an insatiable yearning. From Rouen, he planned a new project that was close to his heart. He wrote to the prefect to get permission.

On the other side of the road from his home and the local railroad that followed along the back of his garden flowed the Ru, a slow branch of the Epte River that divides before meeting the Seine. The only access was by the road or the railroad tracks. Monet, who had been dreaming about this piece of land, finally bought it on February 5, 1893.

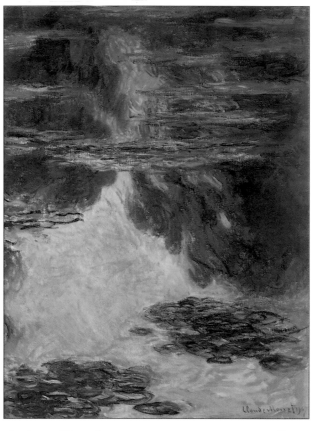

The project was huge. At a time when earthworks were carried out with shovels and wheelbarrows and when soil was moved in carts harnessed to cattle or horses, the project consisted of digging a pond and filling it with water precisely regulated thanks to a diversion of the Ru and a system of locks in order to make a water garden. The local farmers and the city council, terrified by the idea of exotic plants poisoning their land and cattle, united against the project conceived by a stranger with bizarre ideas.

But Monet knew how to persevere, how to be a diplomat when necessary, and how to use his connections. The project was eventually approved. The work finally started in late 1893. The water lily pond would be modified and enlarged later. In 1895, Monet had his Japanese bridge built above the pond's narrow end.

*Water Lilies, Evening Light, 1907, oil on canvas*
*Marmottan Museum Collection, Paris*

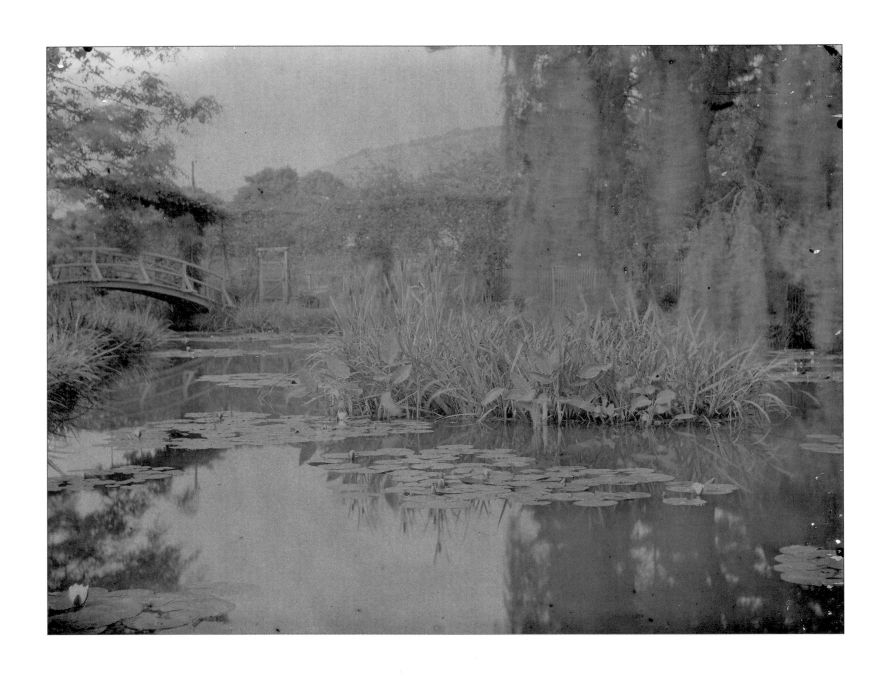

*Water lily pond and Japanese bridge, autochrome in the 1920s*

*Marmottan Museum Collection, Paris*

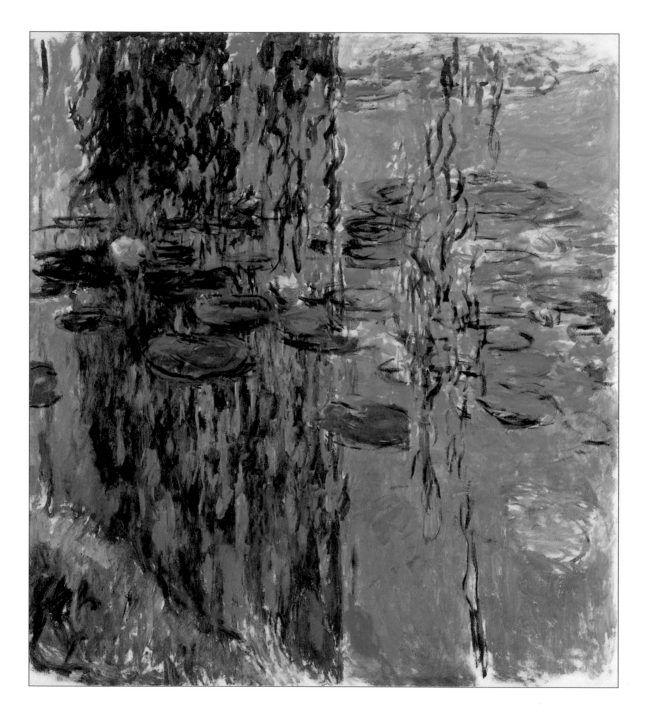

Water Lilies, *circa 1917, oil on canvas*

*Marmottan Museum Collection, Paris*

Here again Monet designed a garden—a water garden—for the sole pleasure of creating and enjoying this garden; for his sole passion of gardening. A garden floating on the waters, suspended, water becoming sky, sky becoming water, this moving, ever-changing, unreal space where the elements merged, became little by little the major theme of Monet's paintings, like the culmination of a slow maturation.

The water garden became a "motif," or recurring theme, for the first time at the beginning of January 1895. In these years of Impressionism, it was said that the outdoor artist "worked on the motif." The "motif" of the first painting born from the water garden was the Japanese bridge. Monet would not paint his water garden until 1898. He completed a dozen paintings in 1899. Monet dated his paintings in the year of their completion. The impressionist painter was no longer so rigid. From his original attitude, which could have become dogma, he picked and chose what he wanted to use. He sketched on the spot and finished in his studio. His work in the studio now took more time than before the "motif."

Monet pursued his work in this manner for several years. He did not like to be questioned on this aspect of his painting. Before his canvas, he was sole judge and master. Only the work counted; he discarded theory even if it had served him in the past. On February 12, 1905, he wrote to Durand-Ruel: " . . . whether my cathedrals, my Londons, and other canvases are based on the real subjects or not, it is nobody's business and it is of no importance. I know so many painters who paint from reality and only make awful things. . . The result is what counts." On April 15, 1912, he wrote again to his dealer: "I am now close to showing my Venices; how I would have loved to see it again, for as always, unfortunately at the moment of turning

*Water lily pond and weeping willow, circa 1933*

them over, I am always unhappy, working up to the last minute without making great improvement; it will be to me a true relief when they will all be packed and I will no longer be able to see them or retouch them."

Until 1900, Monet only painted "Japanese bridges" from his water garden. One usually sees the Japanese bridge with the water confined by the left bank; the horizon and the sky are blocked by the lower part of distant trees.

In 1903, for the first time, Monet abandoned the Japanese bridge in his paintings. He painted the water lily pond in full frame, constrained by a thin line of the bank.

In 1905, he painted the lilies without the bank. Nothing limited the water anymore; it now occupied the whole surface of the painting.

In 1914, Monet undertook building an immense studio next to his house. Because the war delayed the construction, the studio would only be completed in 1916. Monet so loved Giverny that he blamed himself for the ugliness of the building. Monet, who in Argenteuil painted from a floating studio to be closer to his subject and used a similar boat on the Epte River in his Giverny years, started to paint indoors, leaving the "motif" that henceforth he was carrying within himself. From 1916, his works ranged from 6 by 6 feet (2 × 2m) to 6 by 18 feet (2 × 6m), sometimes more, often in several panels that could reach up to 24, 36, sometimes even 48 feet (8, 12, 16m) long. Monet painted water lilies that he could not have painted or even sketched outdoors—not even in his water garden.

This easel painter, the painter of rapidly noted impressions, painted in his studio works that ranked among the largest executed in the twentieth century without the help of assistants. The water lilies became Claude Monet. Or Claude Monet became the water lilies. He recreated his pond, his water, his flowers, and his sky—all in his studio.

Sisley, Pissarro, Cézanne, and van Gogh were dead. Without being truly aware of it, Monet, the founder of Impressionism, killed in himself the last of the Impressionists.

Monet sold very well. He was admired in Europe and the United States. Three days after the exhibition opened, all his "Haystacks" were sold. He was considered the most important living painter of his time. But Degas commented that "Monet only made beautiful decorations." Guillaumin criticized his total lack of construction. For Braque, "Monet is stupid."

After Monet's death in 1926, his water lilies were criticized, then forgotten. The public avoided his great panels of the Orangerie. Worse: they were forgotten. Even his gardens were abandoned: the supports for the rosebushes devoured by rust, his paths and flower beds

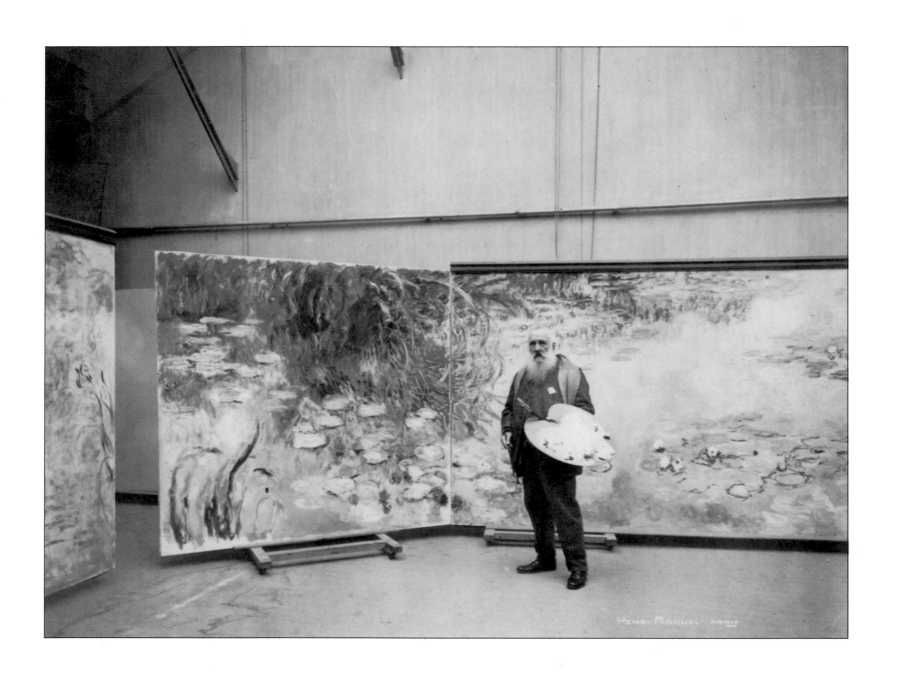

*Monet in his third studio in front of the panels of one of his largest series*

*Photograph by Henri Manuel*

obliterated by weeds. The pond became a quagmire where his water lilies languished, then died.

In 1954, John Rewald published his *History of Impressionism* (*Histoire de l'Impressionisme*). He condemned almost the whole work Monet painted in Giverny. "In this attempt (that of the series) to methodically observe the uninterrupted changes of light, Monet lost the spontaneity of his perception. Now he felt disgusted by 'the easy things that come in a flash,' but it was precisely in those 'easy things' that he had revealed his genius at seizing the first impression, the bright splendors of nature. . . If his canvases often presented a brilliant solution to a problem, this problem was rarely pictorial and imposed severe limitations on him. . . Pushing his disdain for the so-called subject, Monet abandoned form completely. . . At the time when he thought he had reached the apogee of impressionism. . . he lost the freshness and the strength of his original impression." (John Rewald, *Histoire de l'Impressionisme*, Albin, Michel. 1965. Pocket edition, pp. 215–216, vol. 2).

*"What is God, if not an eternal child who eternally plays in His eternal garden?"*

RABINDRANATH TAGORE
(*SADHANA*)

This judgment was applied to "Haystack," to "Cathedrals," to all Monet's series. It is astonishing that it was formulated almost thirty years after Monet's death. It is hard to understand.

Around 1950, the perception of Monet's work changed. Camille Bryen, Arpad Szenes, Jean Bazaine, and Zao Wou-ki all acknowledged their debt to Monet, which Wassily Kandinsky had avowed as early as 1912. All artists finally recognized his influence. Twenty-five years after his death, Monet left his earthly purgatory. But I know that during that time, he was strolling in paradise where, to his great joy, the light is supposedly ever changing.

The rescue and the restoration of his gardens and house began in 1977. The gardens have been open to the public since 1980. Henceforth, the friends of Monet throughout the world and the friends of flowers gravitate toward Giverny.

In His paradise, God has appointed Monet painter of the angels' wings and gardener of his gardens. Water lilies float among the flowering clouds of

dahlias, tulips, azaleas, irises, and peonies. The blessed travel from cloud to cloud by Japanese bridges, singing canticles, while Ronsard, his sweetheart at his side, with a melody composed at his request by Erik Satie, praises the roses that do not lose the radiant beauty of their purple attire.

By divine permission, Mr. Claude Monet descends sometimes into his earthly paradise, carried on the wings of long-ranged angels. At the blessed time, with camera in hand, as I wandered the Giverny gardens, the night of the full moon on the June solstice, I encountered on the paths a mist in human form whose feet did not touch the ground and who cast a shadow. The ghost explored the earth garden, headed toward the water lily pond without being hindered by the walls, then walked on the water without making a ripple. With his straw hat, his stomach prominent like that of a lover of good food, his pants drawn tight at the ankles, Mr. Claude Monet, on leave from paradise, had come back to revisit his gardens. He had stains of paint on his white beard; two ladybugs were making love on his vest.

I photographed the Giverny gardens for an entire year, one day a week, without cheating, or ever trying to imitate Monet, neither with a blurred image nor in composition. In the earth garden, I emphasized color because it is so prominent. It sparkles. In the water garden, color is more discrete, sometimes dissimulating into monochrome. But monochrome, in its modulations, its subtle vibrations, is also color that Monet knew well. More impressionistic than the earth garden, the water garden offers its reflections, ambiance, and rigorous compositions, which the colors overtake in the earth garden.

Whether administrators, gardeners, or visitors, those in the Giverny gardens are men and women happy to be there, on a small piece of land illuminated by flowers, in these paths of living colors, in this garden that renews birth, by this pond that mirrors sky, trees, and flowers while bearing floating bouquets.

I hope that these photographs will be able to transmit a little of this joy of living.

I also feel despondent away from Giverny.

*Charles Prost*

*Claude Monet's shadow on the surface of the water lily pond, photographed by himself*
*Philippe Piguet photo collection*

SP  spring
S  summer
A  autumn

*The Garden*

1 Visitors' entrance
2 "The Water Lily Studio"
3 Hen house, poultry yard
4 Monet's house
5 Crab apple trees, mixed dogwoods
6 Spruce trees
7 Climbing roses and tea rose bushes
  *Flower beds:*
S Pink tulips, blue forget-me-nots, pink and red double daisies
S Pink and red pelargonium
A Japanese anemones, morning glories
8 Pruned linden trees and at their base, spring flowering deutzia bushes
9 Climbing roses and espaliered pear trees along the surrounding wall
  *Flower beds:*
S *Aubrieta*, primroses, blue-violet and purple irises, snowdrops
SA Japanese anemones, asters, Carpathian bellflowers, *Actinidia*
A Dahlias, morning glories
10 The second studio

11 Seed plot
12 The orchid greenhouse
13 Area reserved for seedlings
14 End of the underground passage linking the two gardens
15 Japanese cherry trees
16 Apple, cherry, and plum trees
  *Flower beds:*
SP Tea rose bushes, *Aubrieta*, tulips, daffodils, *Aquilegia vulgaris*, wallflowers, phlox, irises, peonies, centaurea, lupines
S *Heliopsis*, delphiniums, daisies, *Verbascum*, yellow marigolds, rudbeckia, gladiolus
17 Tamarisk
  *Flower beds:*
SP German irises, leopard's-bane
S Peonies, Oriental poppies
A Japanese anemones, marigolds, asters
18 Wildflower meadow with cherry, apple, and Japanese maple trees
  *Flower beds:*
SP Daffodils, German irises
S Clumps of peonies, Oriental poppies
A Japanese anemones, asters, cactus dahlias
19 *Border:*

SP German irises and daffodils
S Climbing roses, asters, cactus dahlias
20 The grand path crowned with climbing roses
  *Borders:*
SP Pansies, tulips, wallflowers, daffodils, imperial crowns, German irises, peonies, primroses
E Clumps of delphiniums, valerian, roses, daisies, white phlox, perennial geraniums, Linaria (toad flax)
A Dahlias, asters, nasturtiums, *Helianthus*, sunflowers, delphiniums
21 *Aubrieta*, daffodils, *Doronicum*, tulips, mountain clematis on supports
S Linaria, climbing roses, hollyhocks, summer flowering clematis, poppies
A Daisies, mountain clovers, cactus dahlias
22 Orchard surrounded by espaliered apple trees
23 *Flower beds:*
SP German irises
S Lilies, Linaria, climbing roses
A Japanese anemones, tobacco plant
24 Cotinus or "smoke tree"

25 Meadow with Chinese peonies, laburnums, Japanese maple trees
26 Benches
27 Pine trees
28 *Borders:*
SP Pansies, wallflowers
S Lilies, Heleniums, linaria, hollyhocks
A Sweet peas, golden rods
29 Doors used by Monet to cross the railroad track (no longer there today) to go to the water garden

*The Water garden*

30 Alder
31 Small bridges
32 Liquidambars
33 Bamboo garden
34 Japanese bridge and white and blue wisteria vine
35 Weeping willow
36 The big purple beech
37 Boat landing and climbing roses
38 Locks
39 Water lilies
40 Wisteria
41 Rhododendrons
42 Willows
43 Poplars
44 Azaleas
45 Yellow water irises
46 Japanese cherry tree

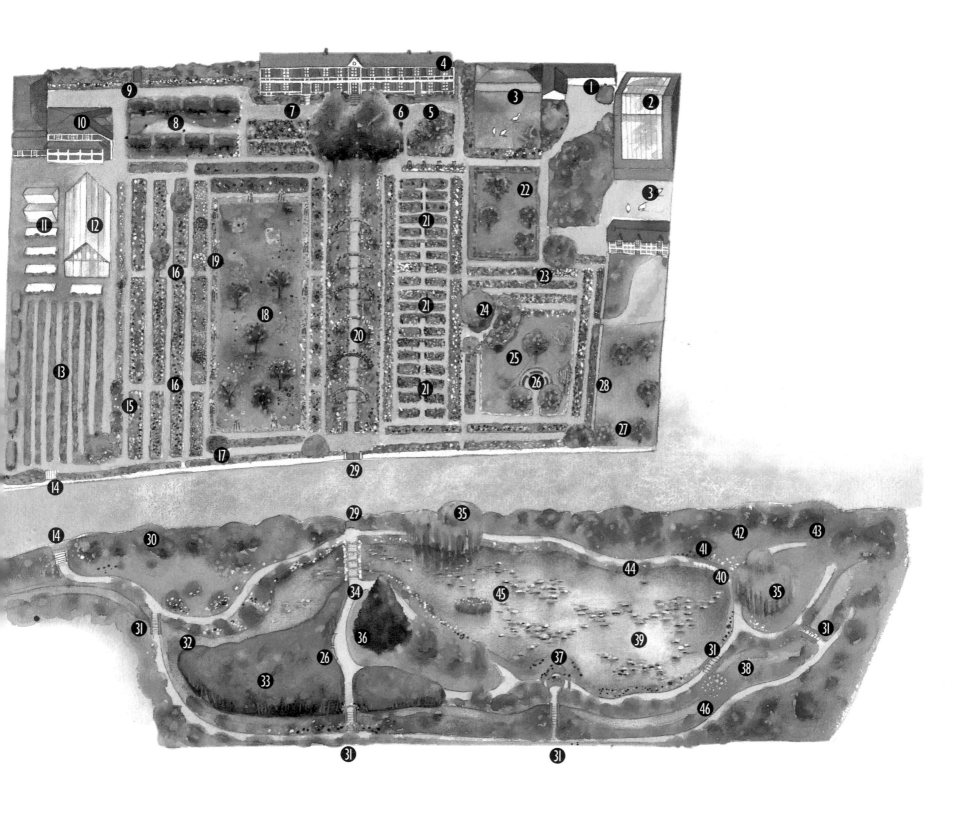

*spring*

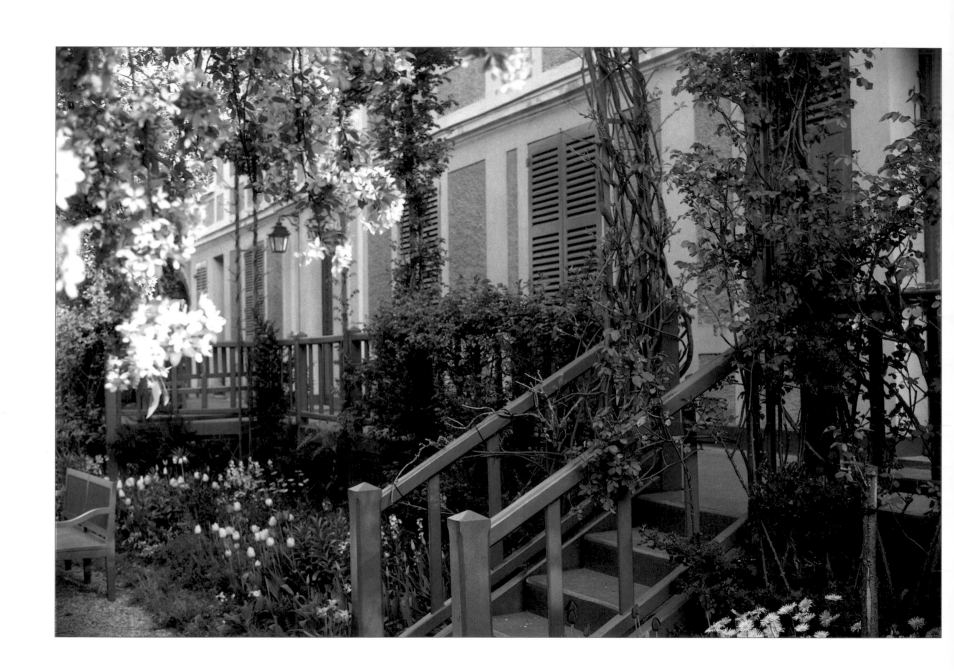

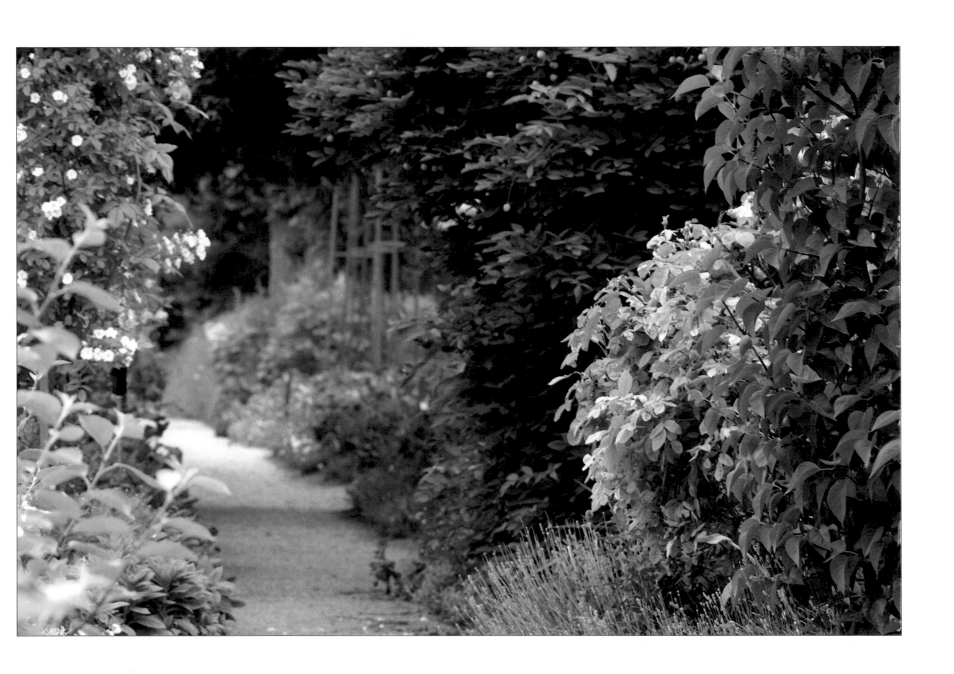

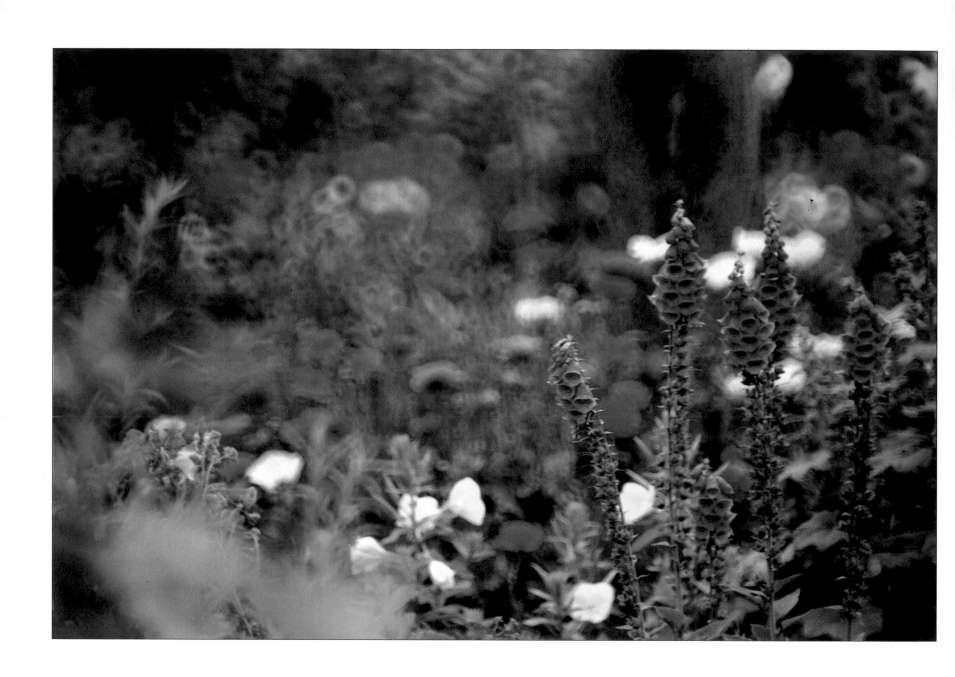

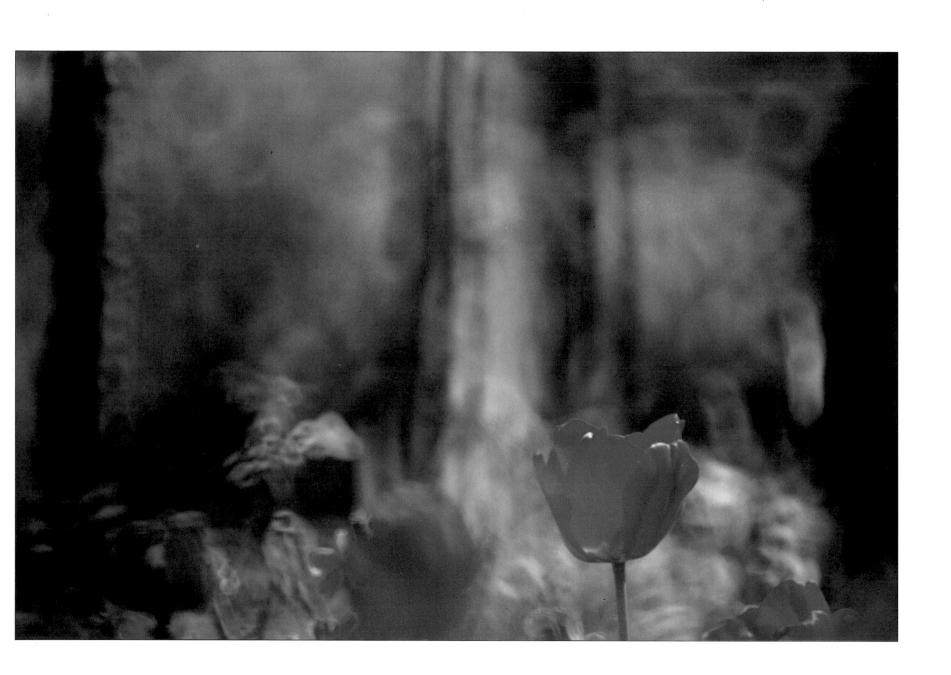

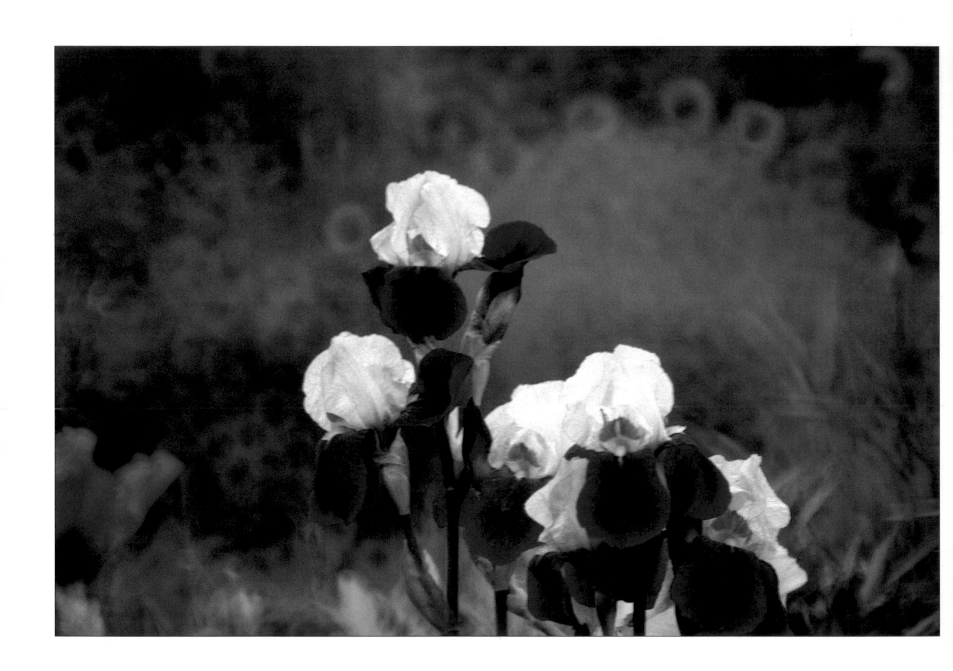

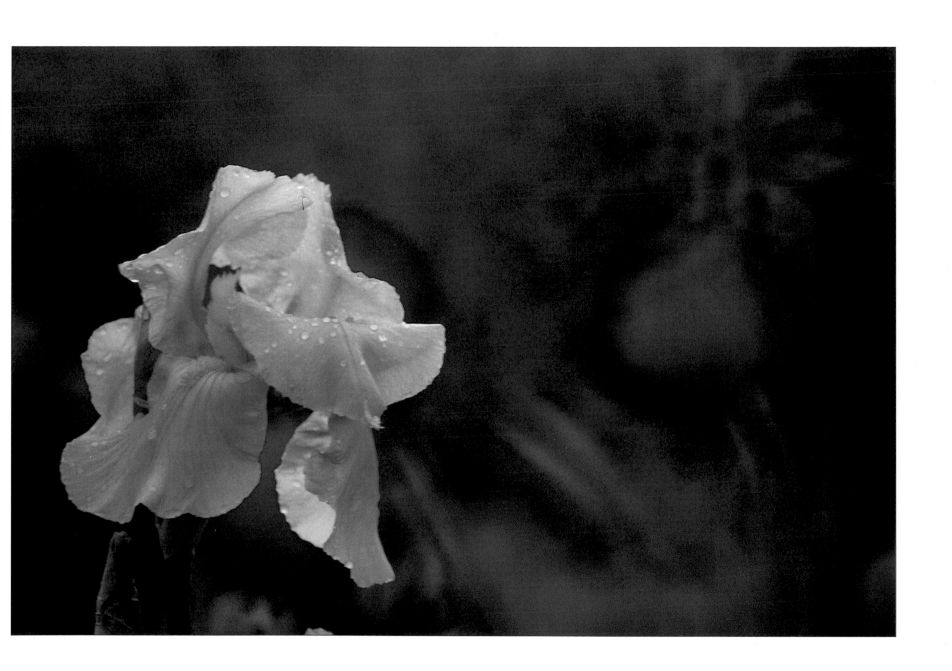

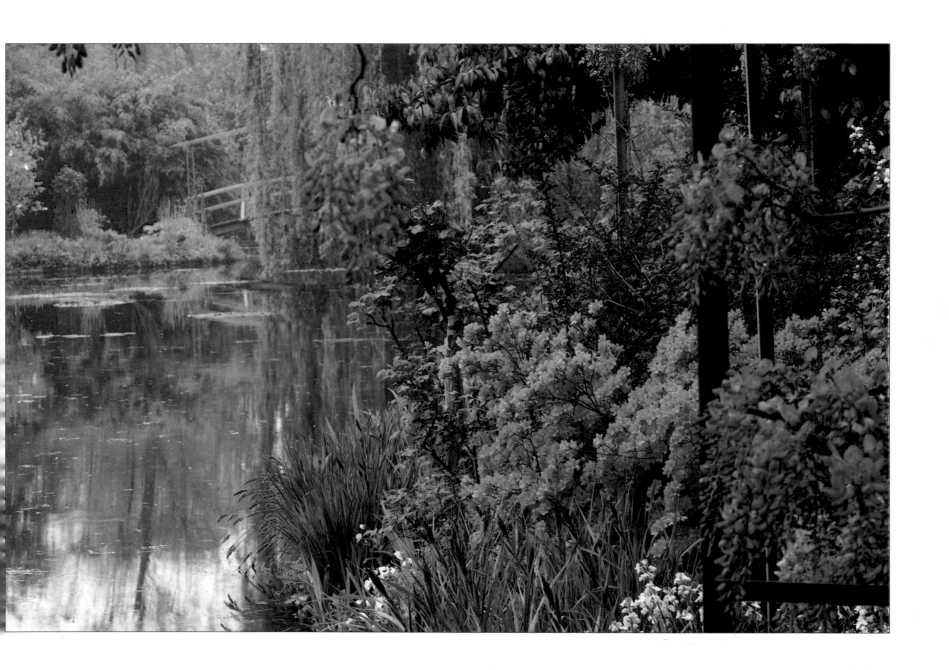

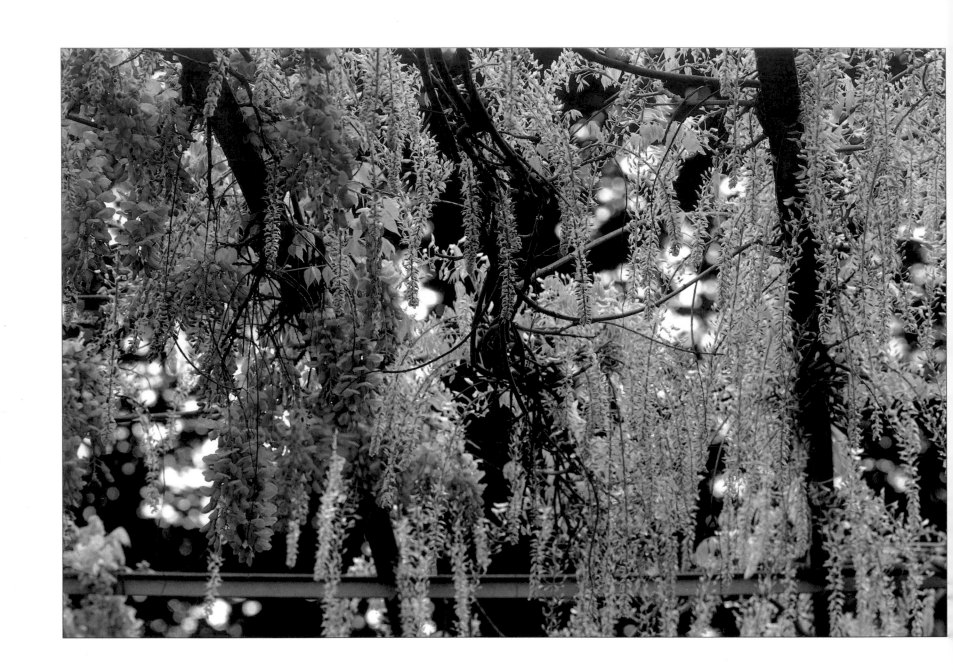

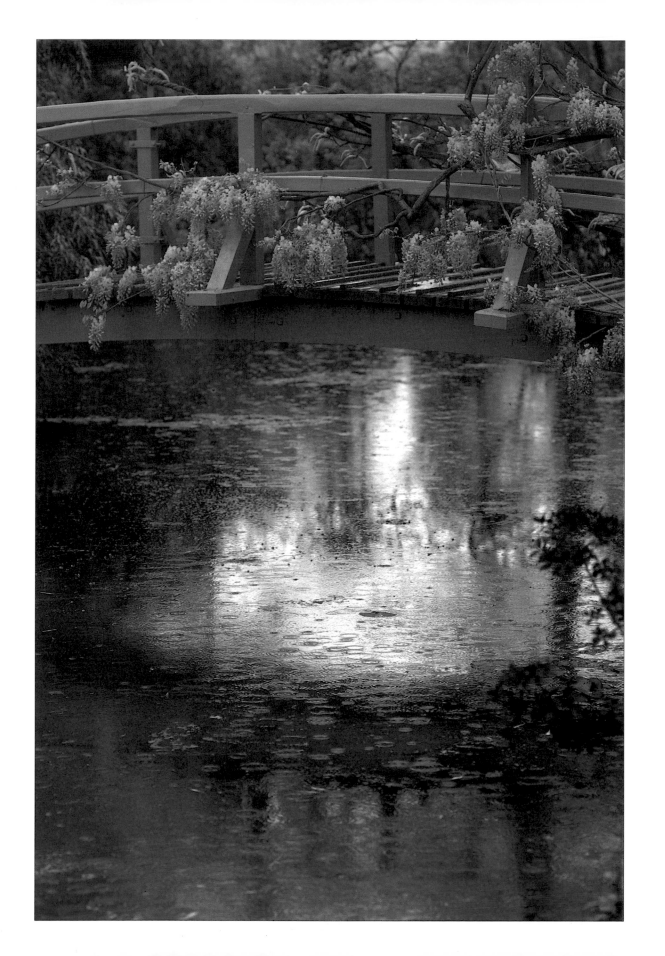

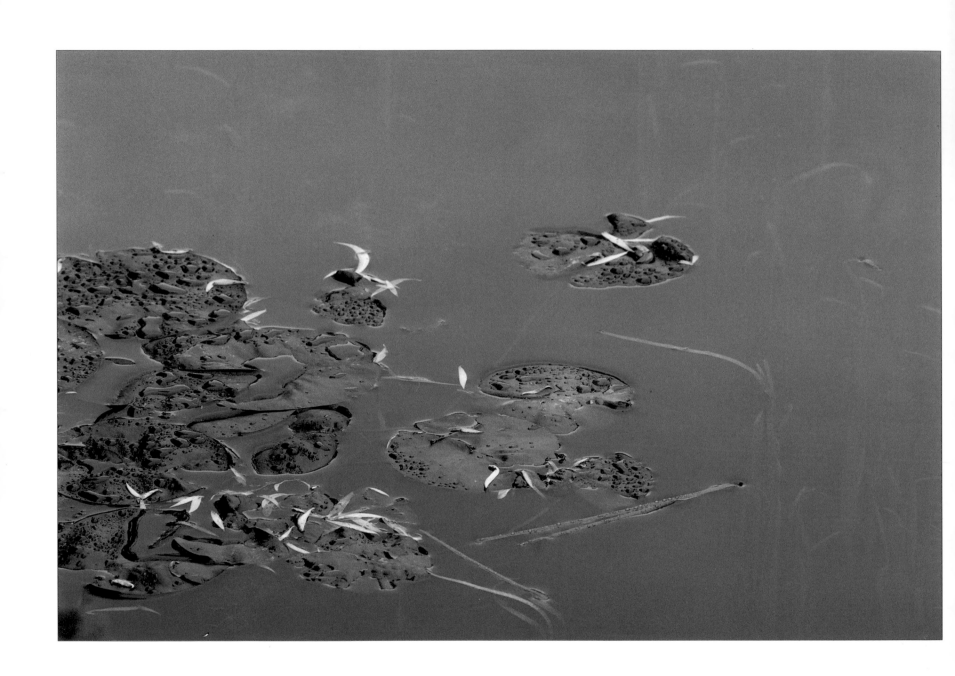

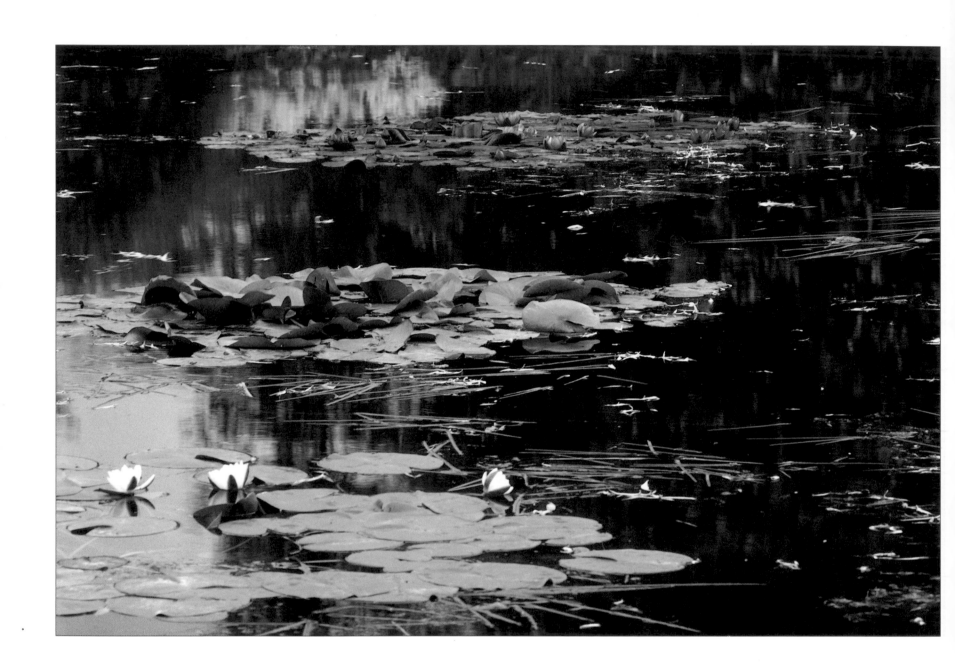

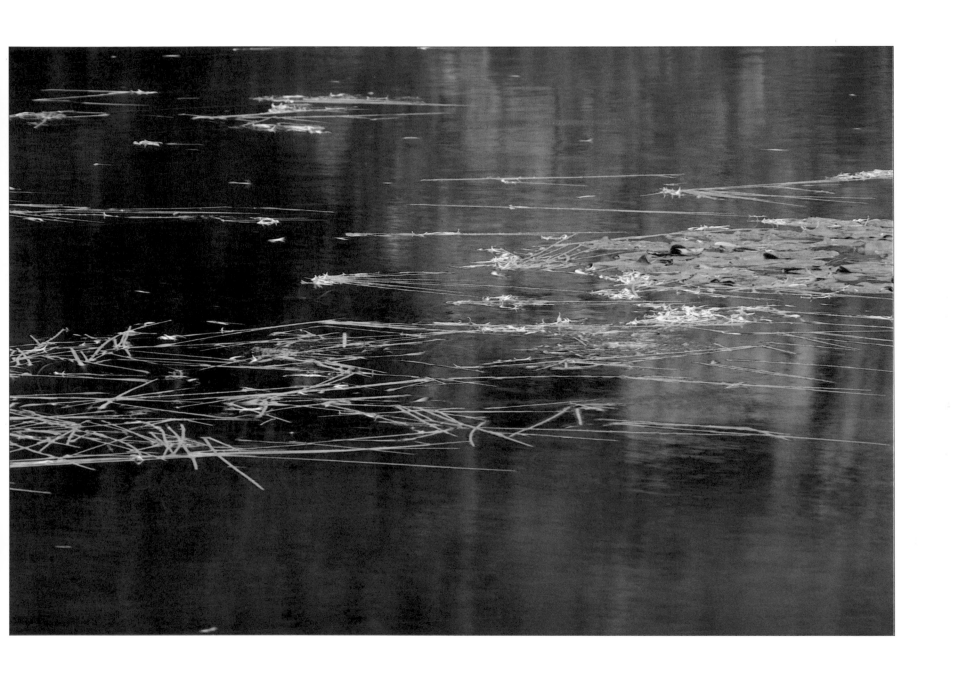

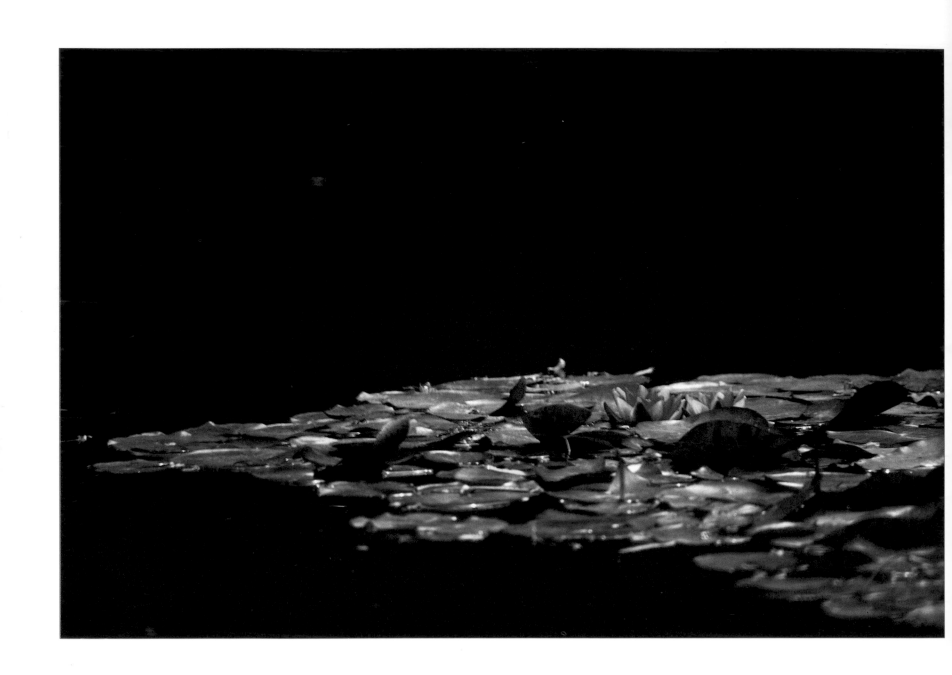

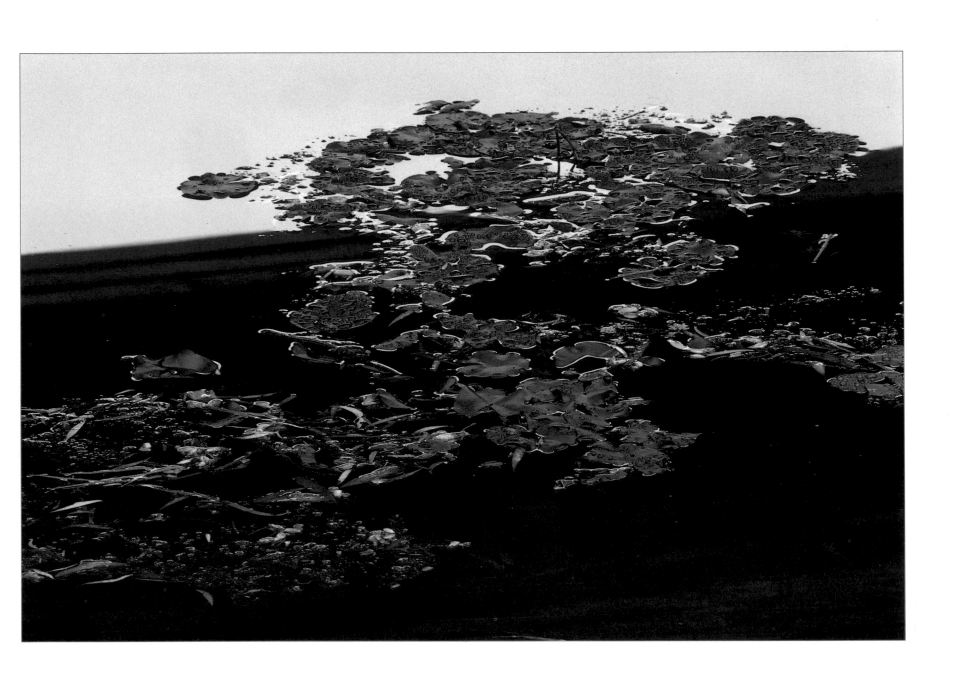

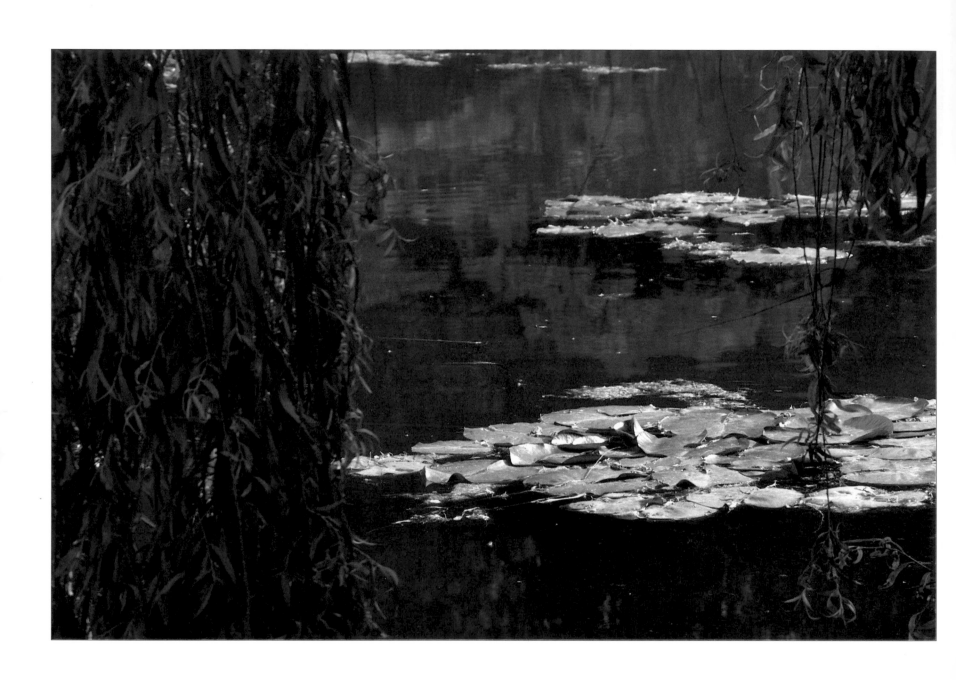

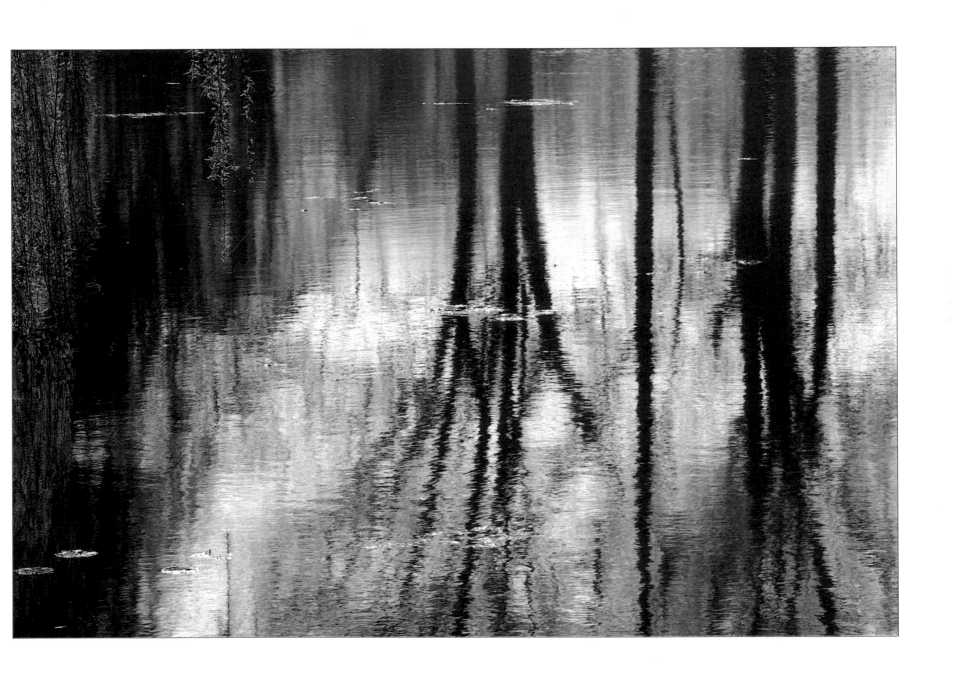

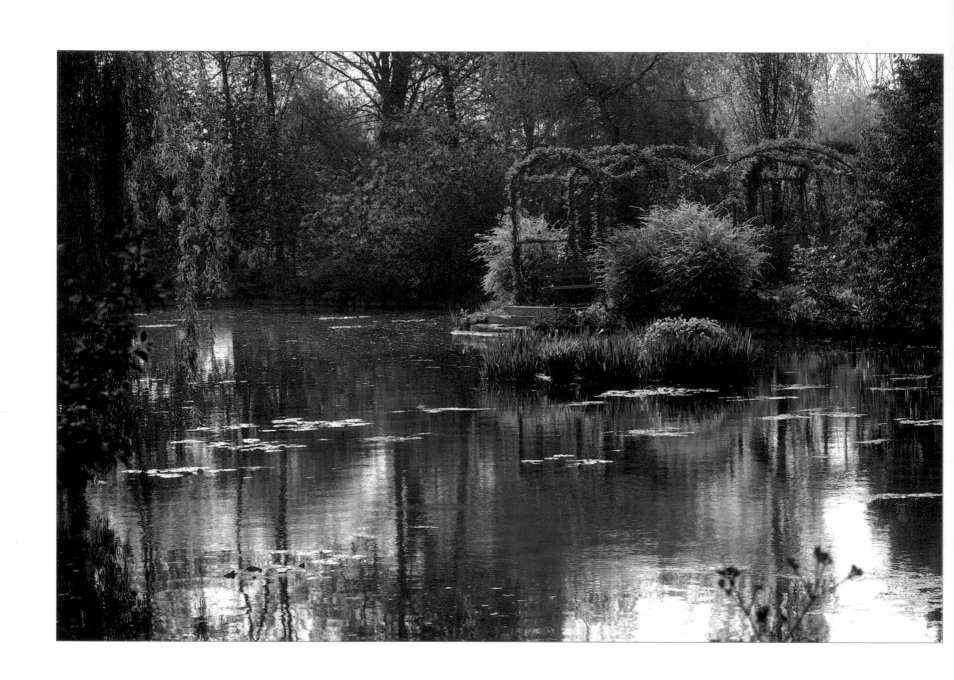

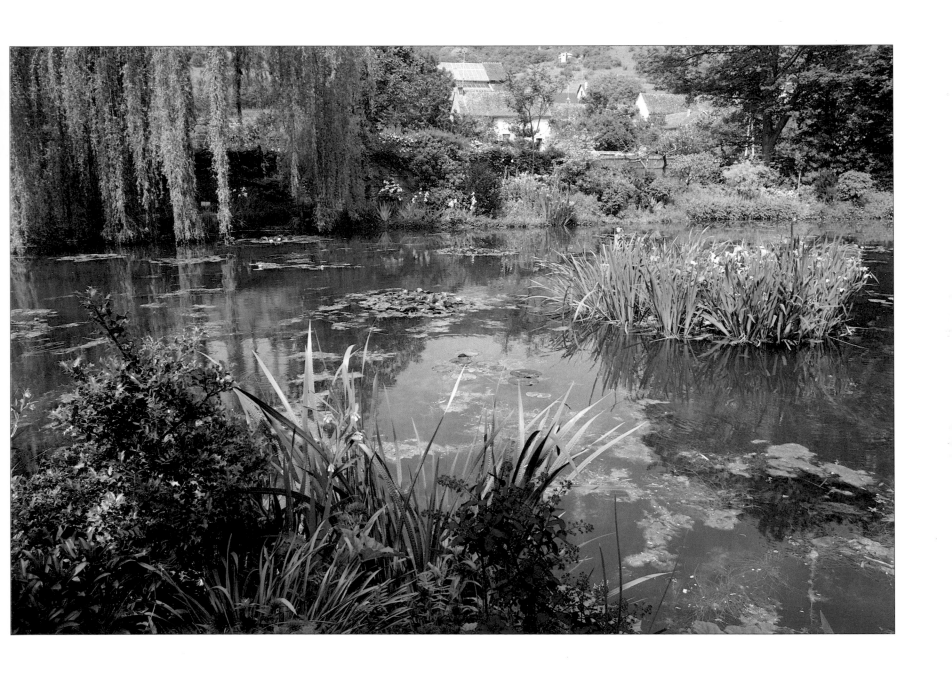

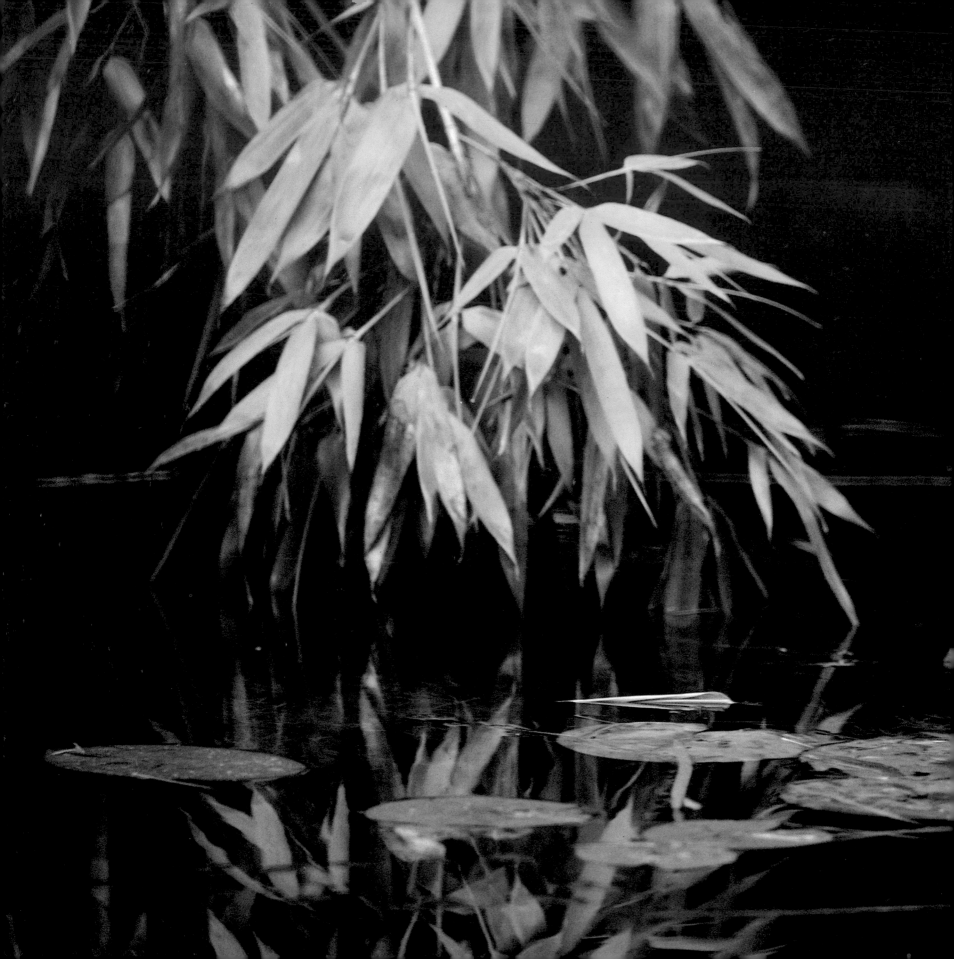

summer

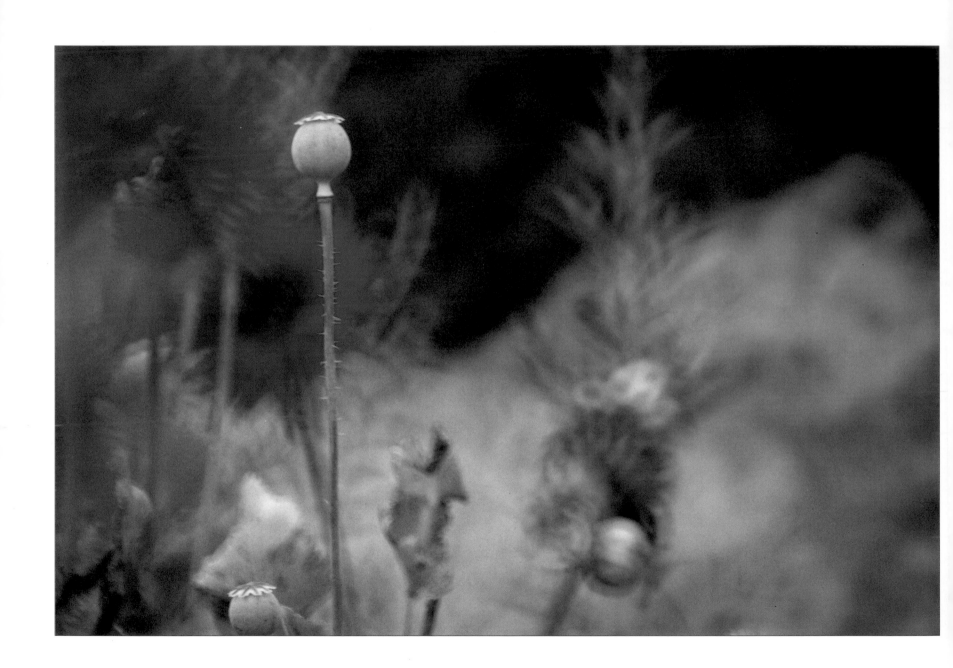

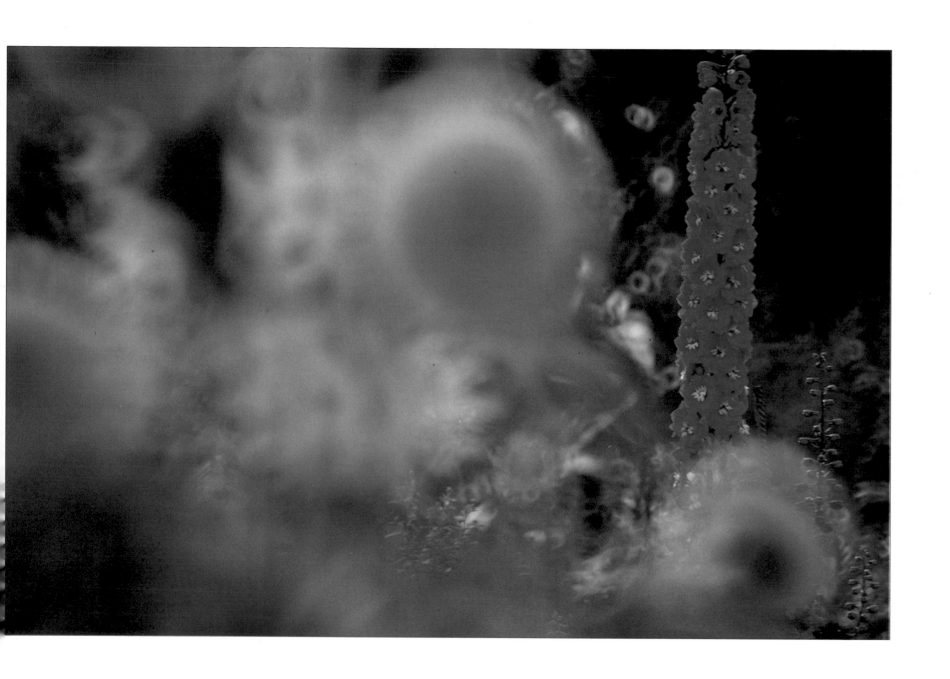

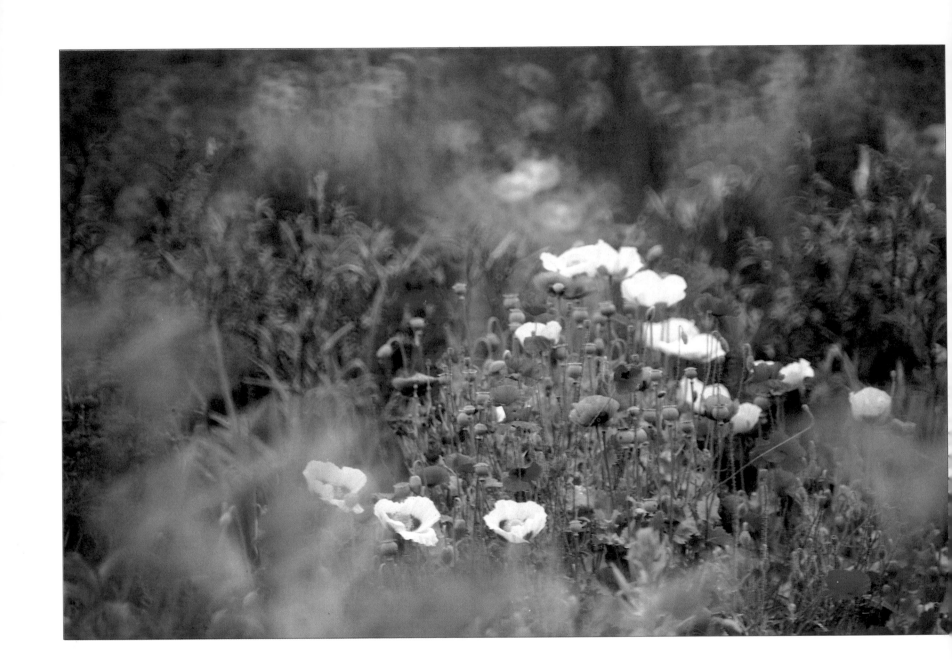

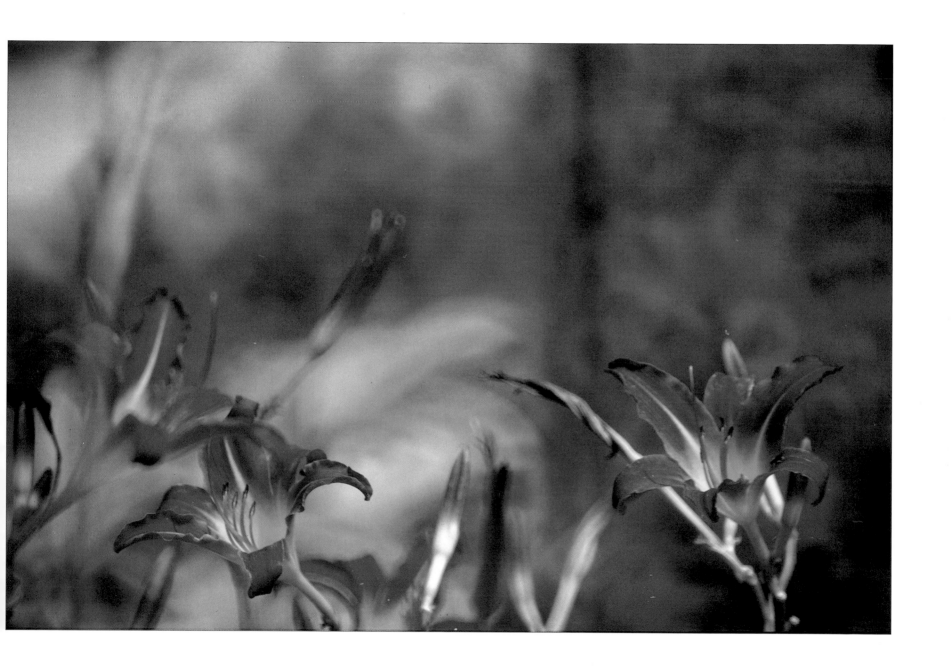

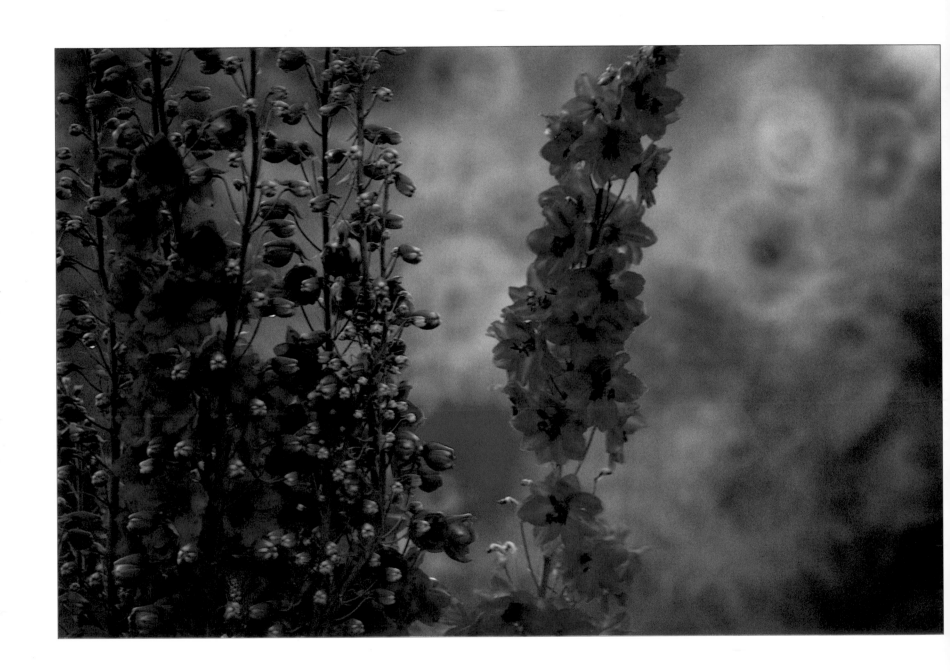

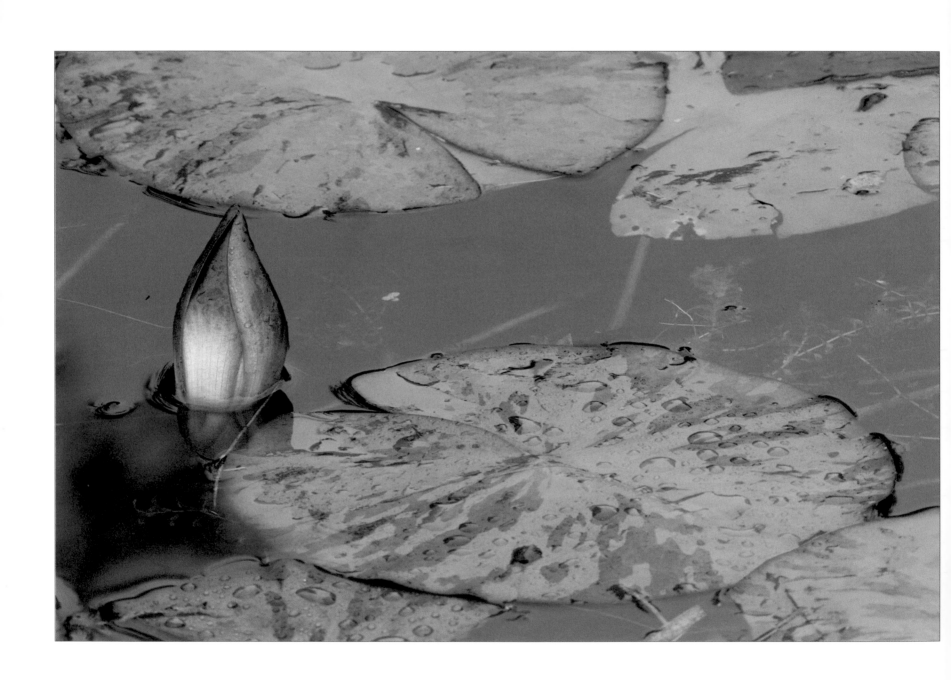

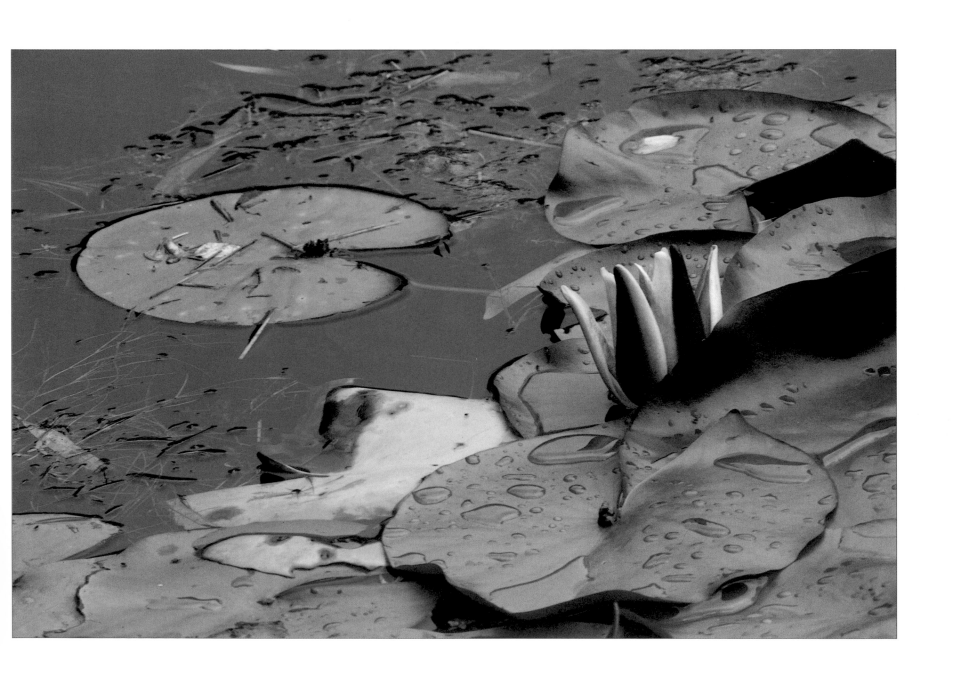

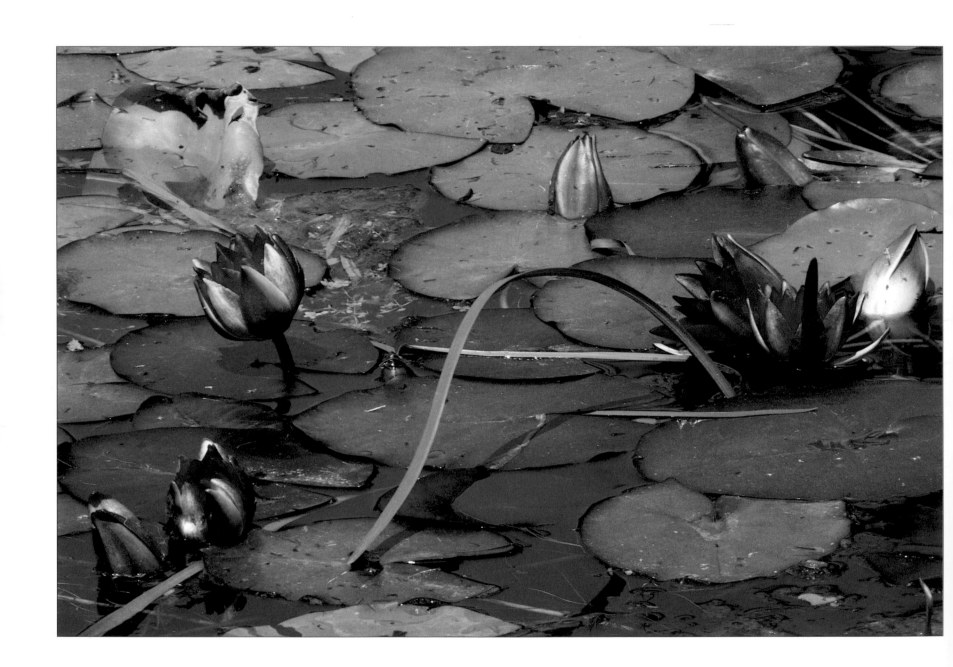

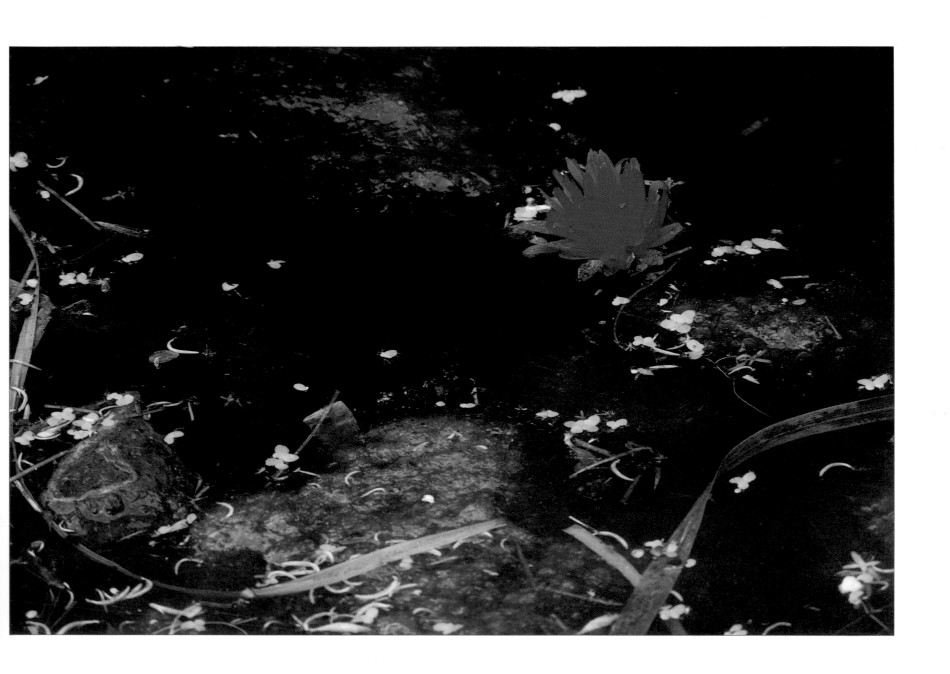

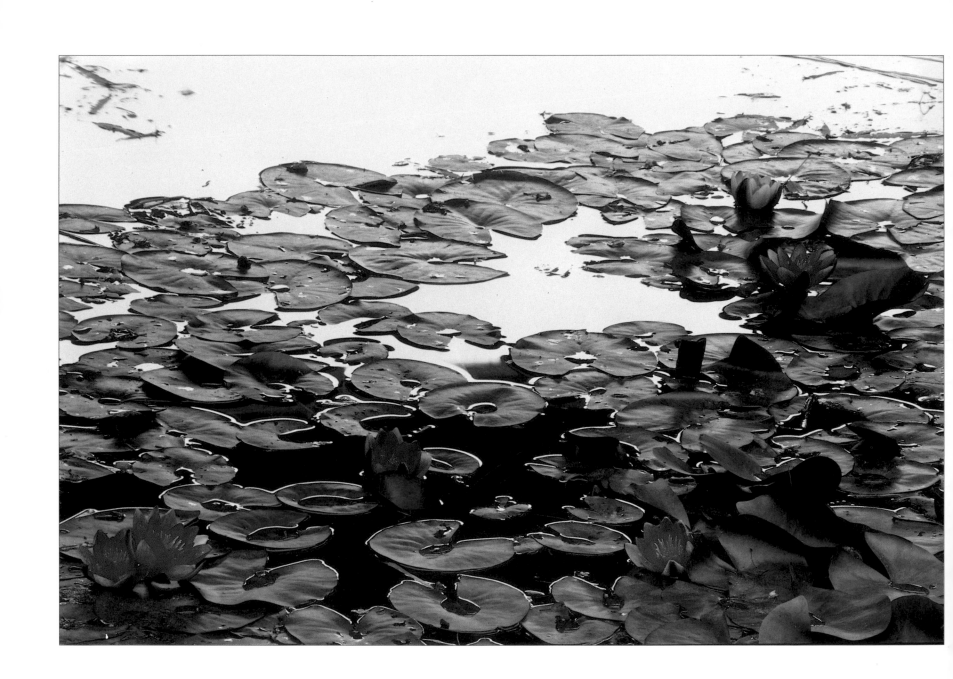

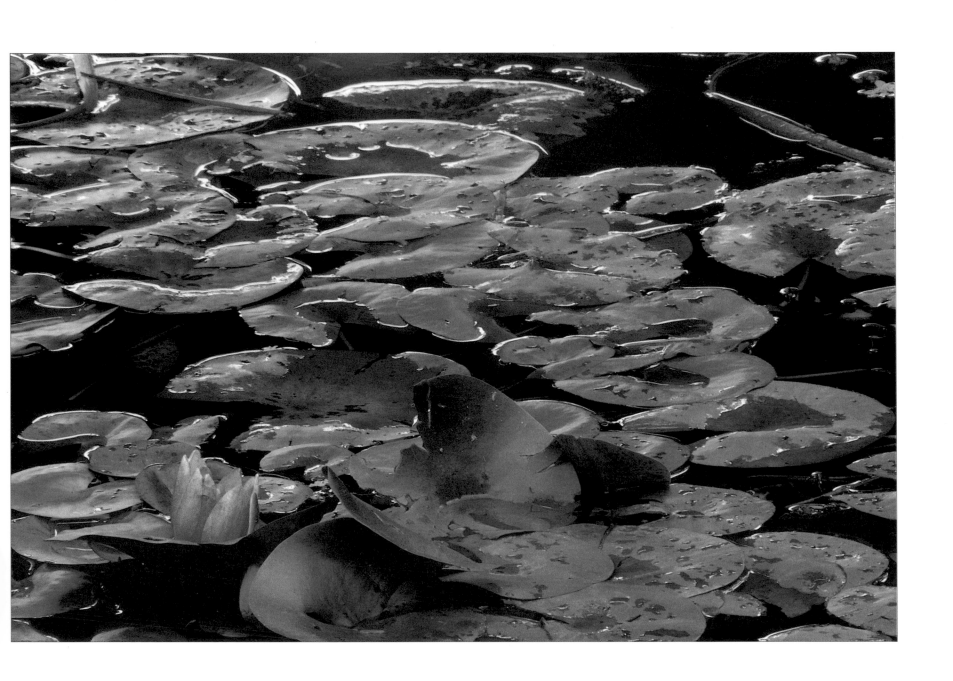

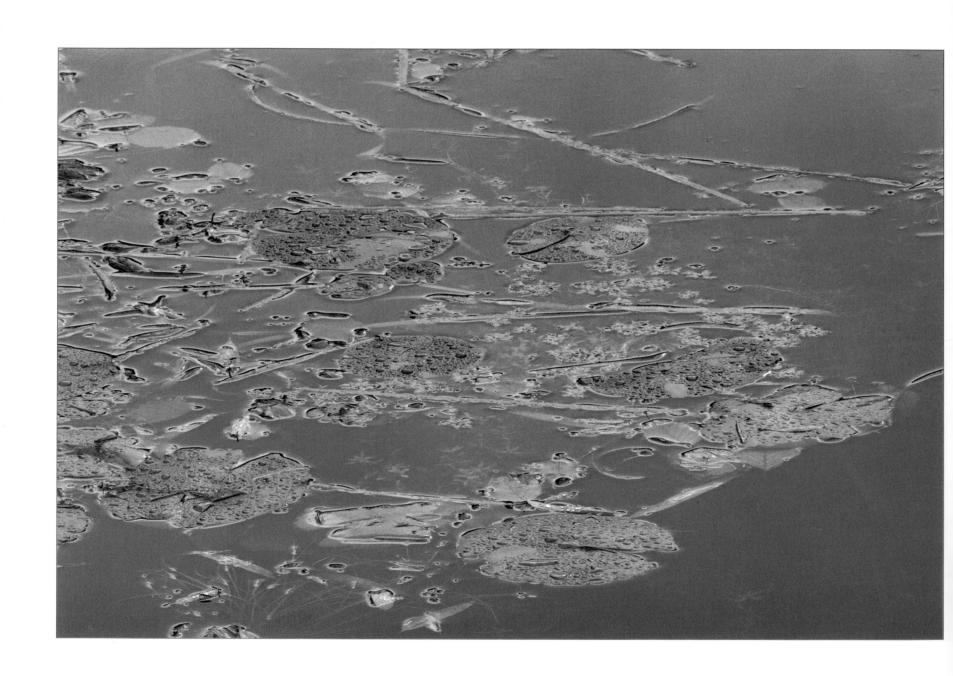

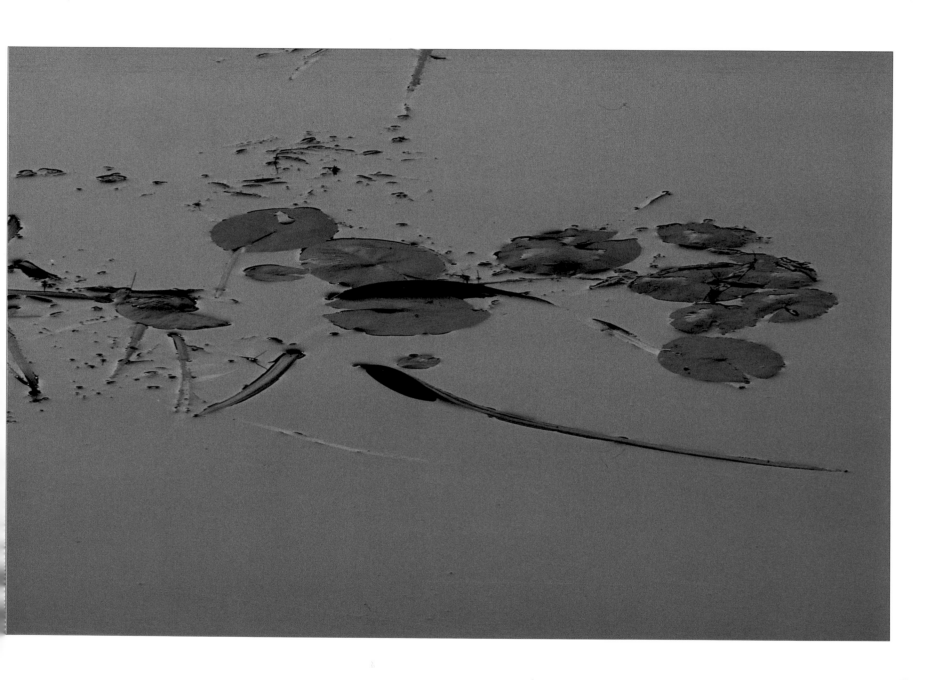

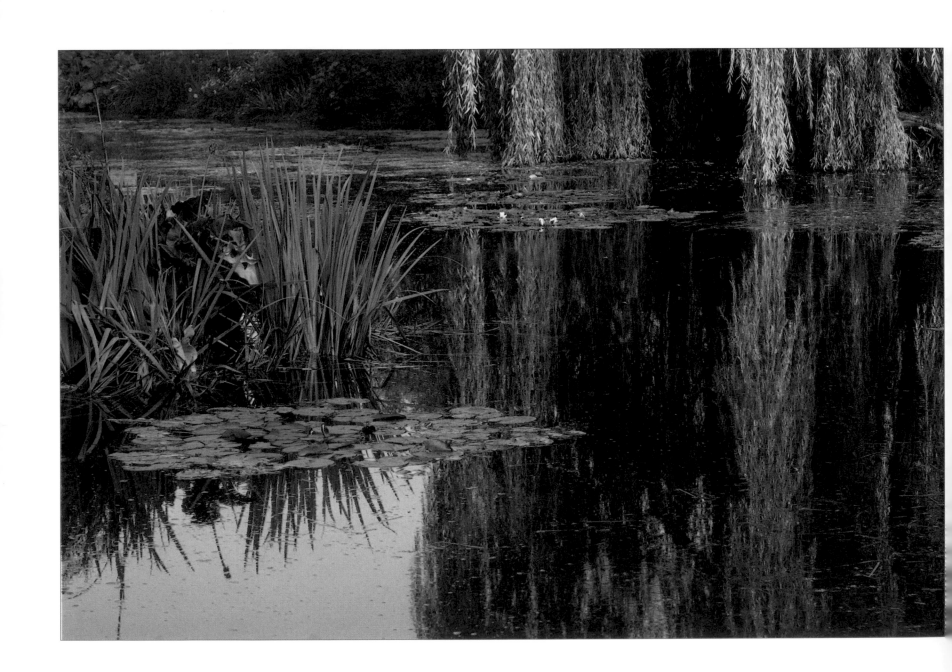

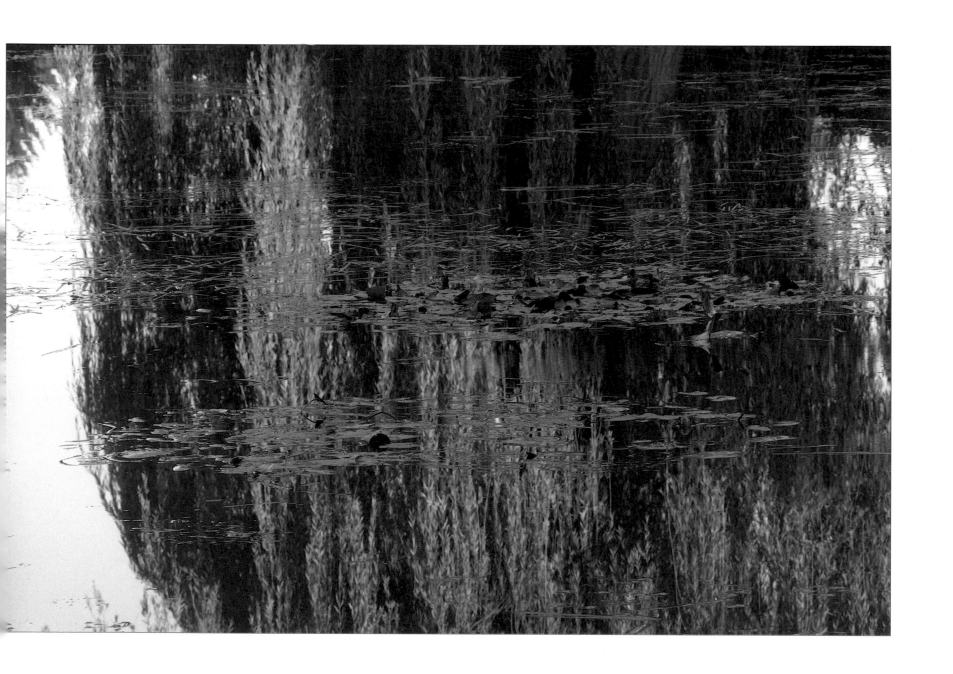

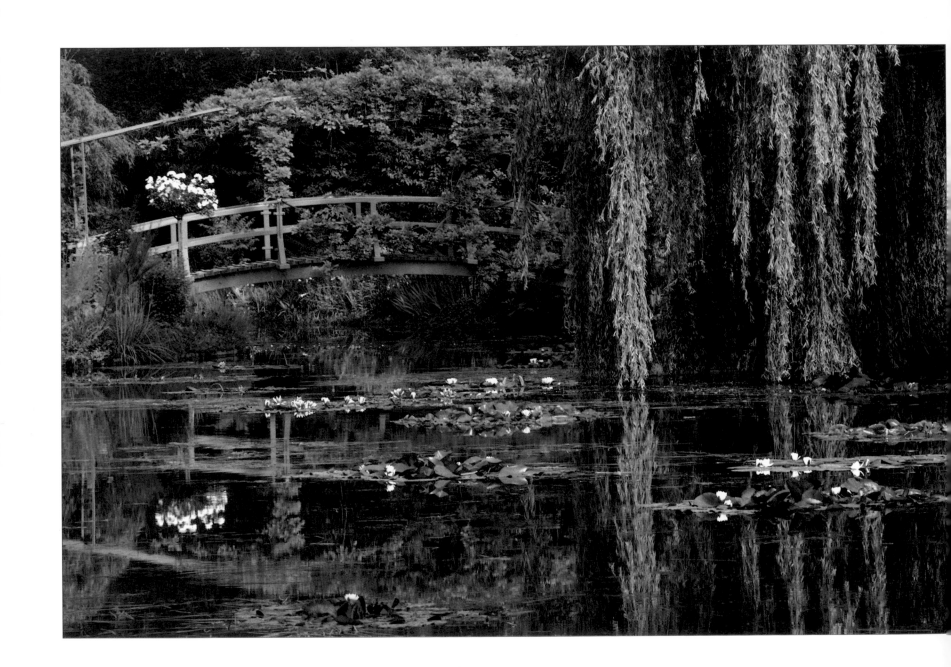

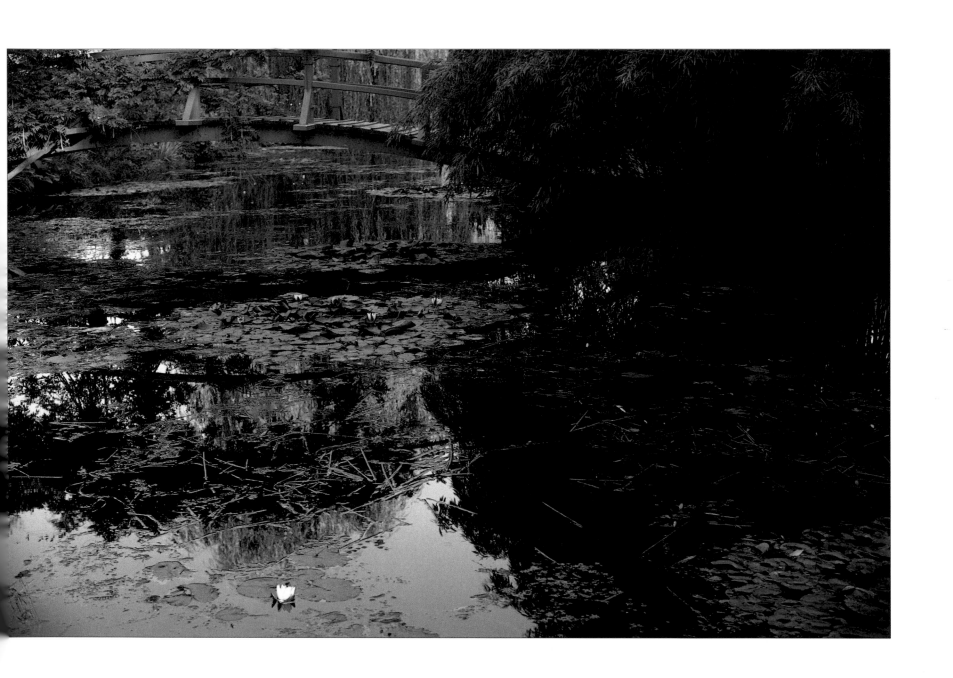

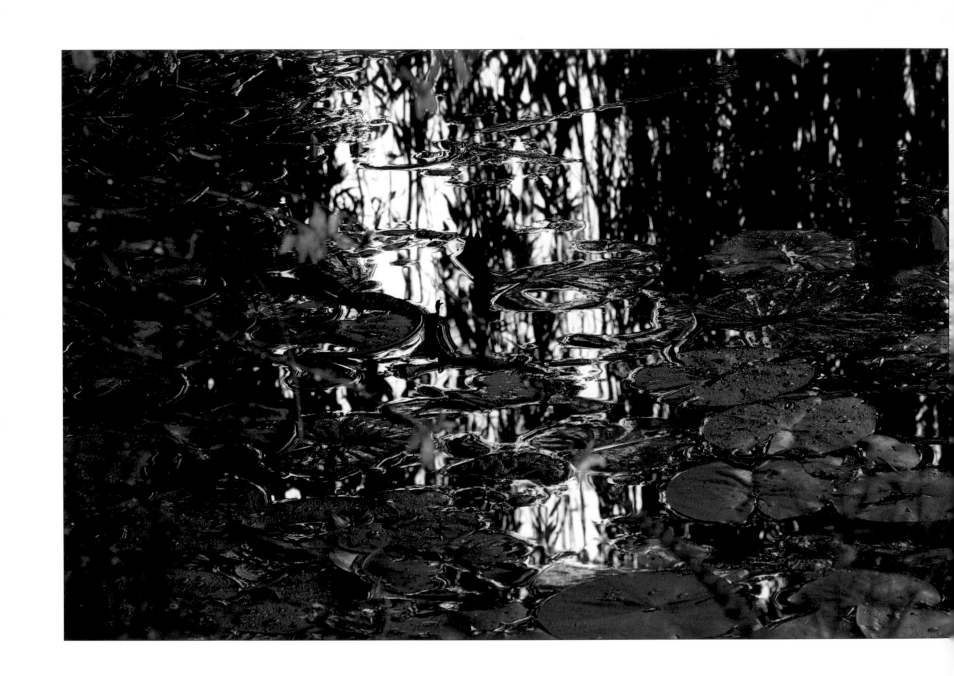

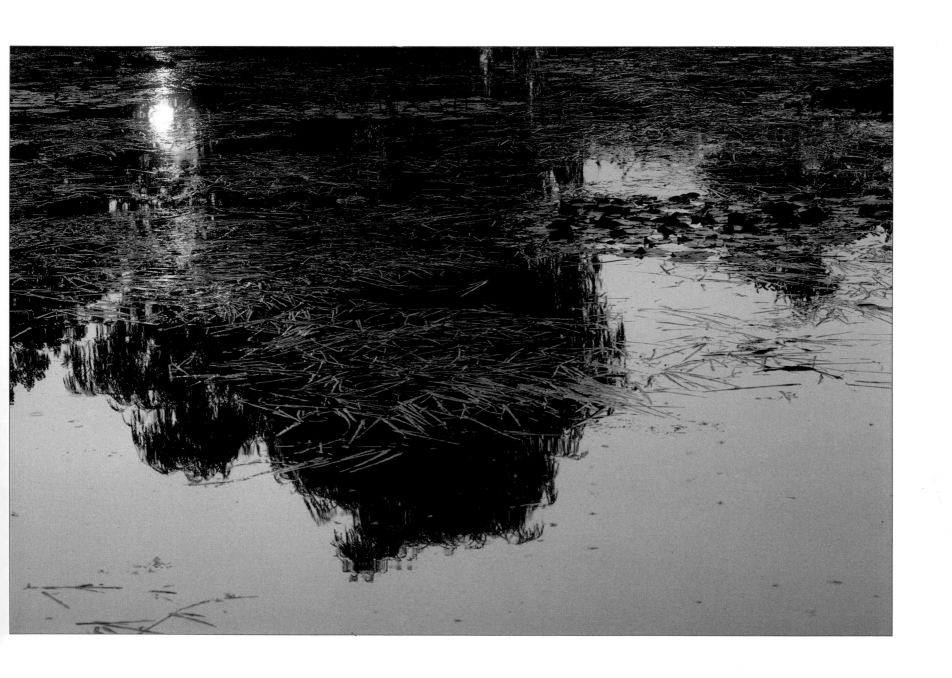

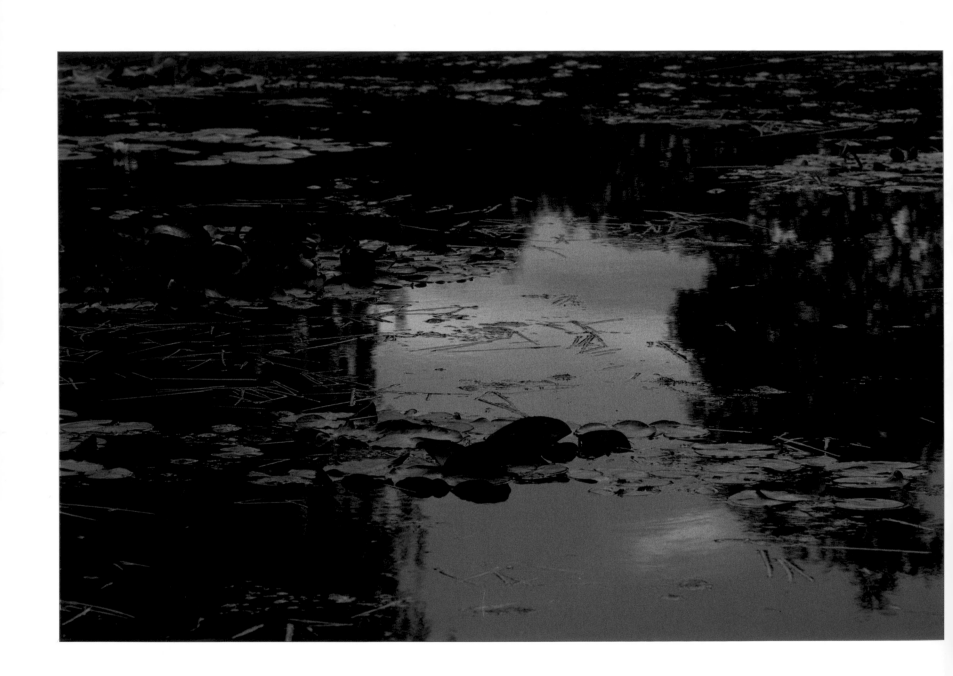

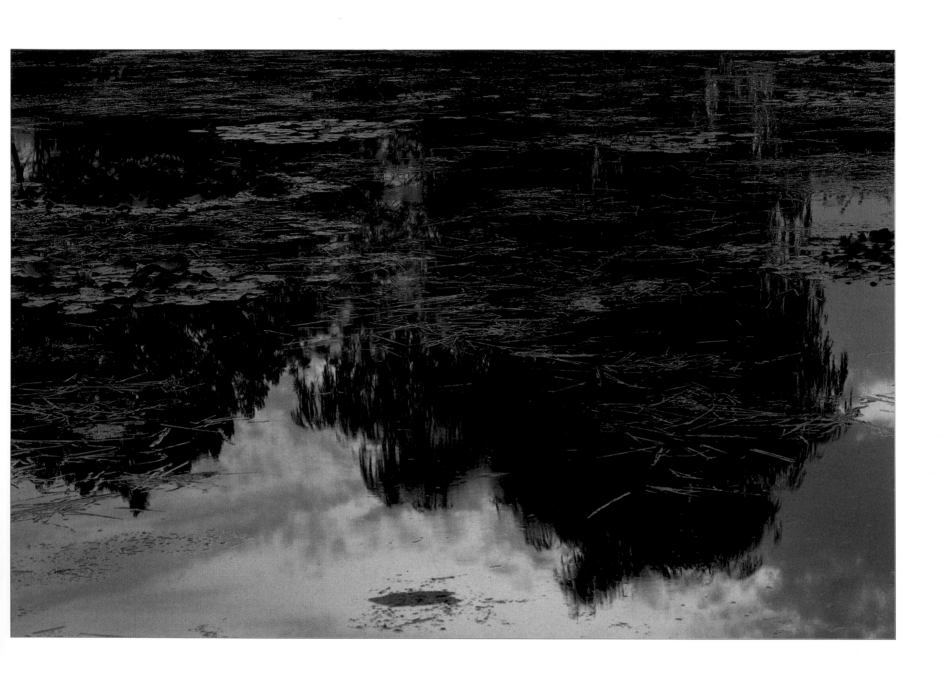

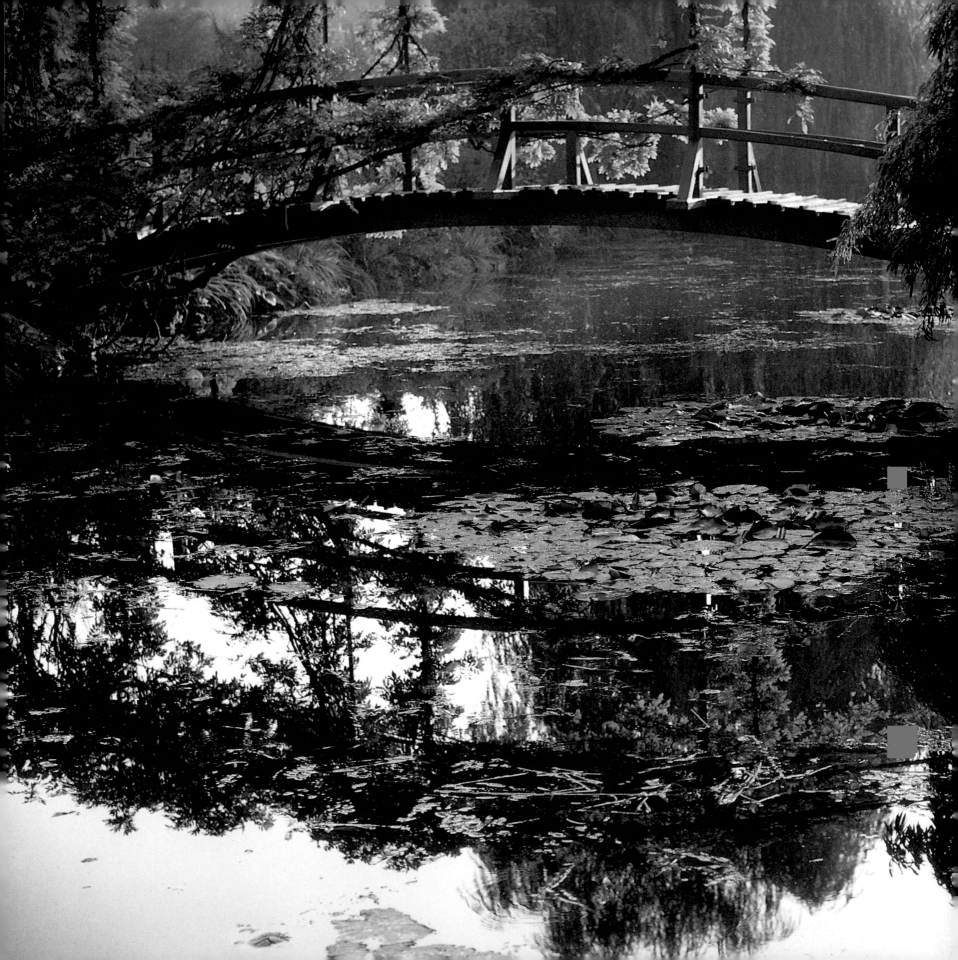

autumn

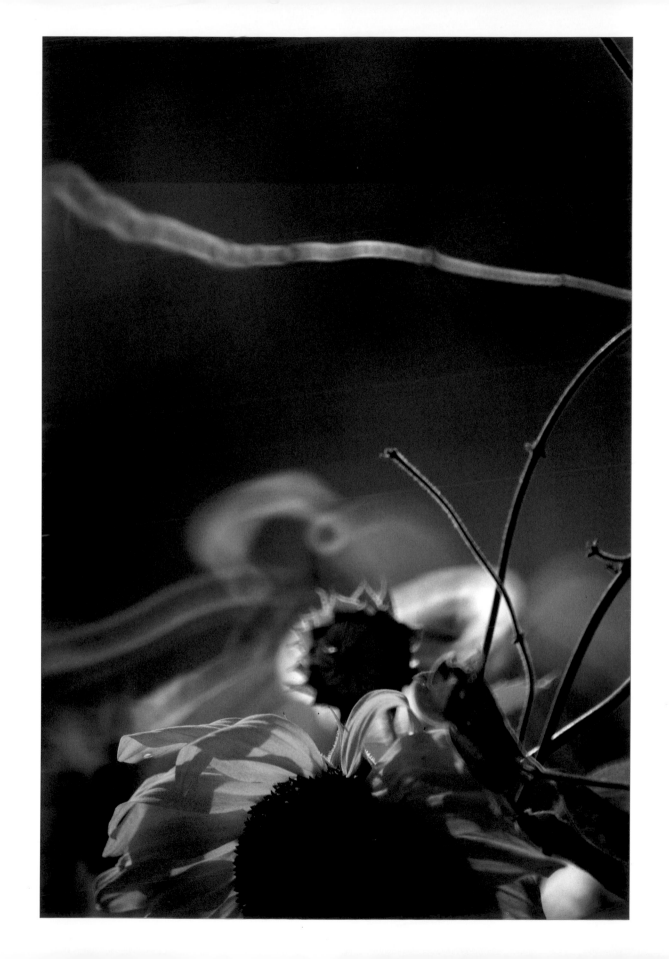

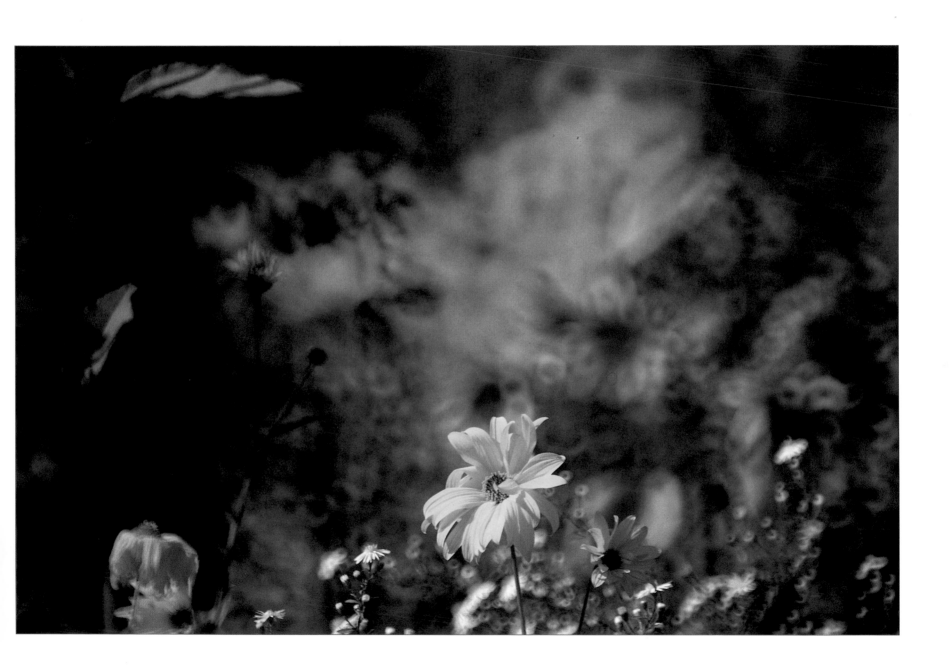

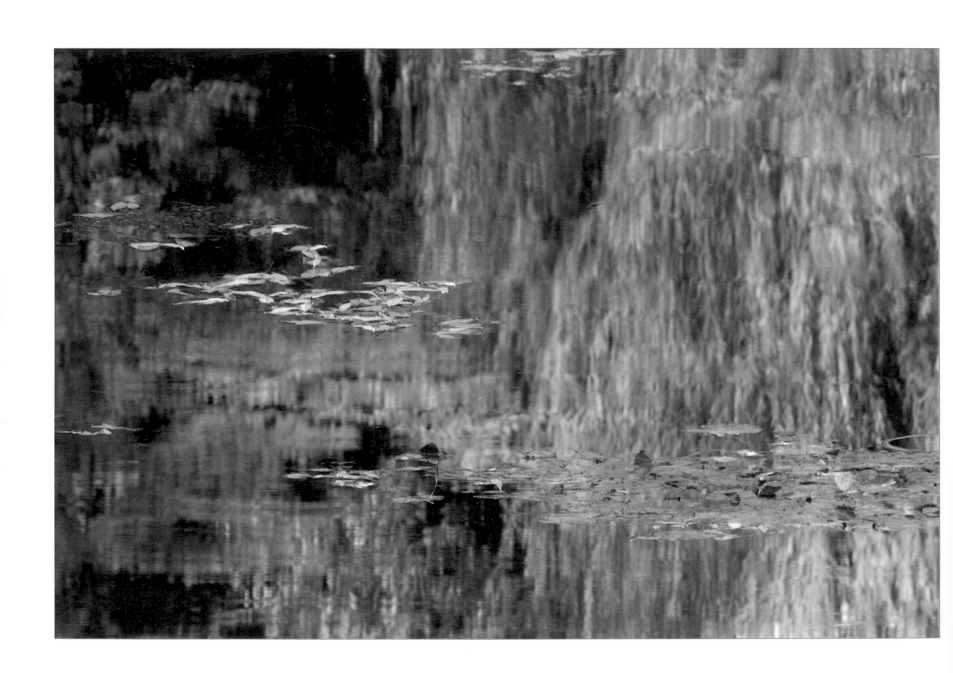

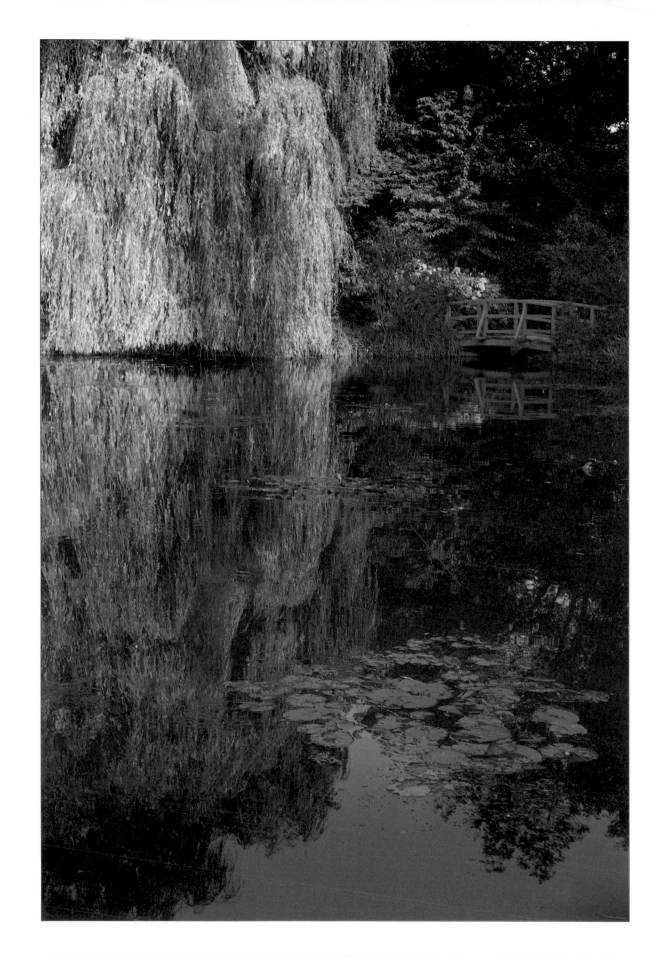

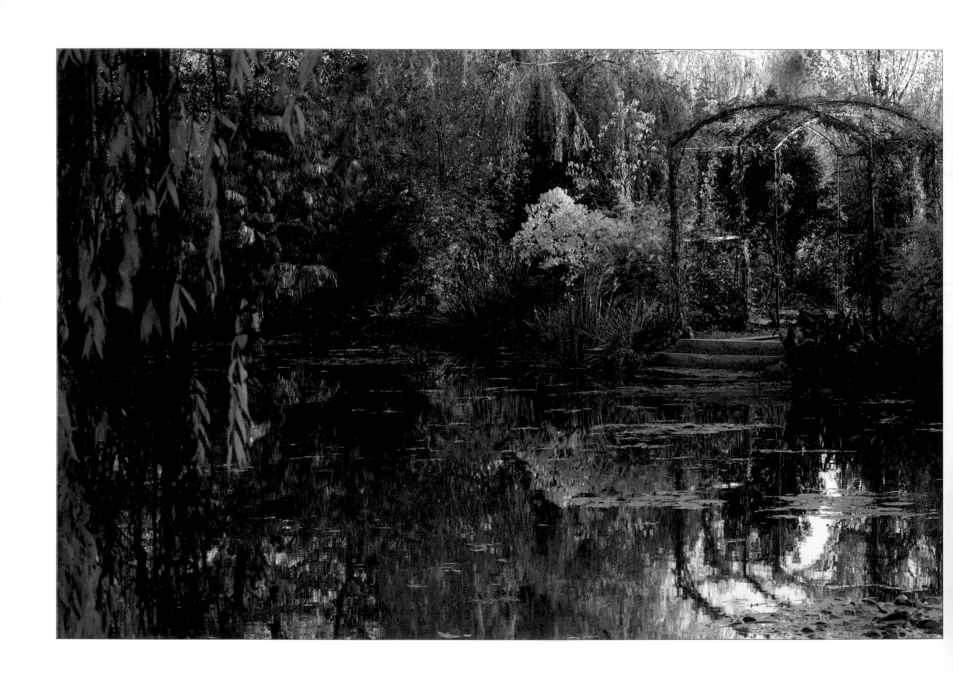

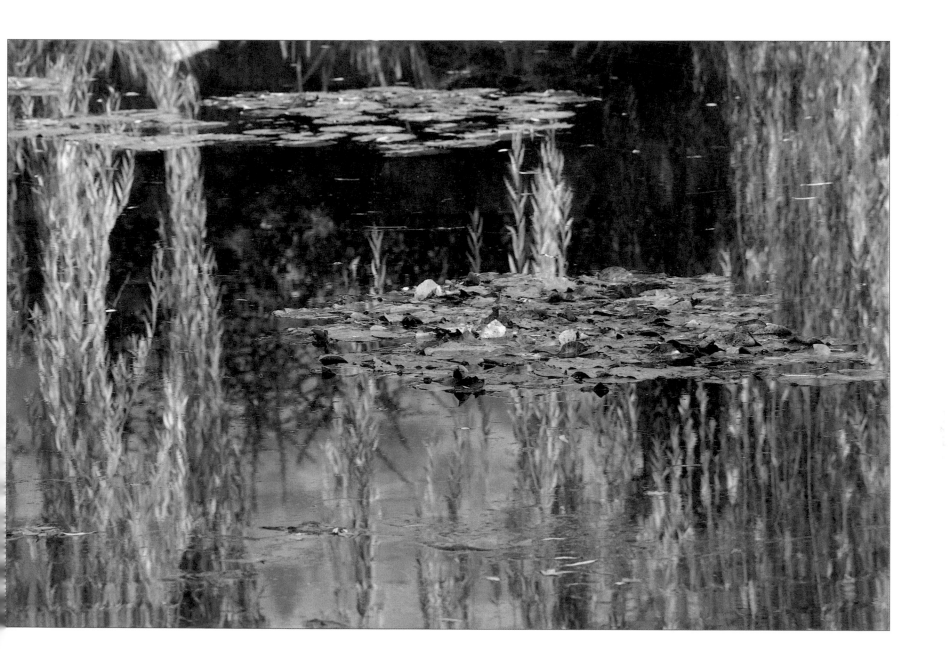

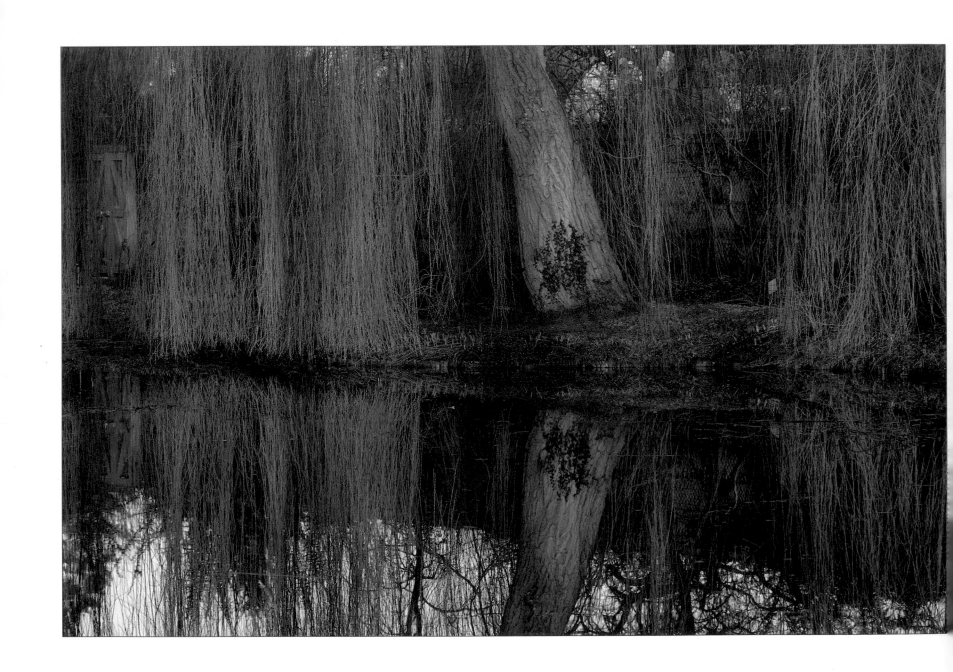

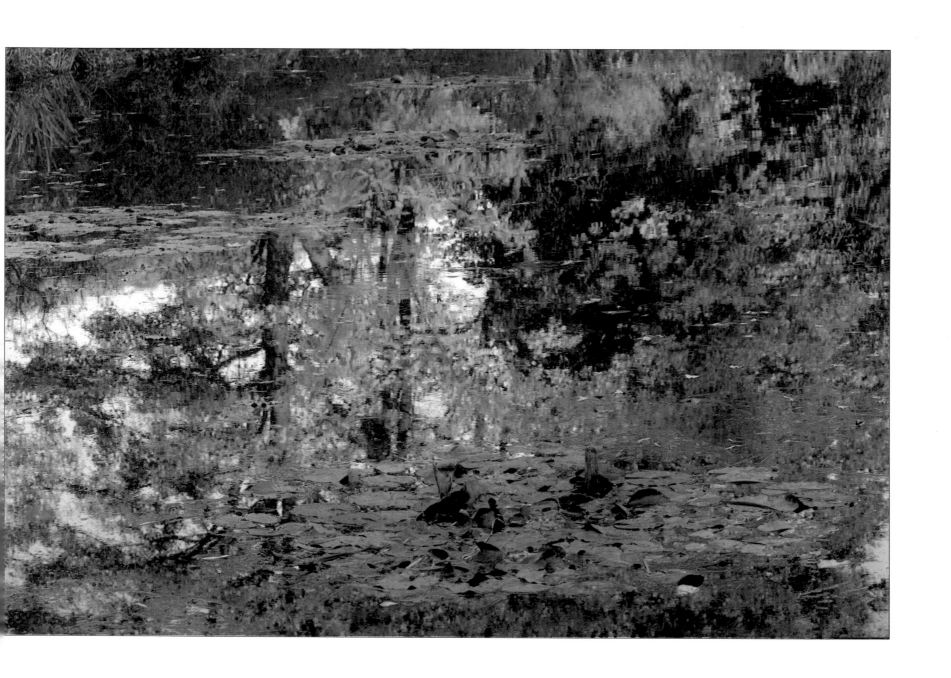

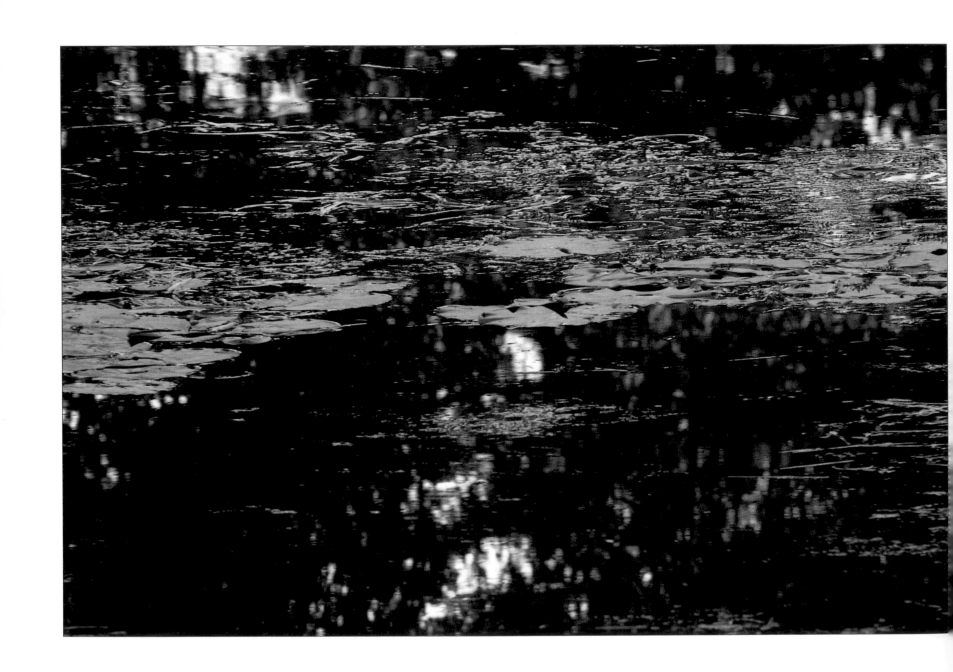

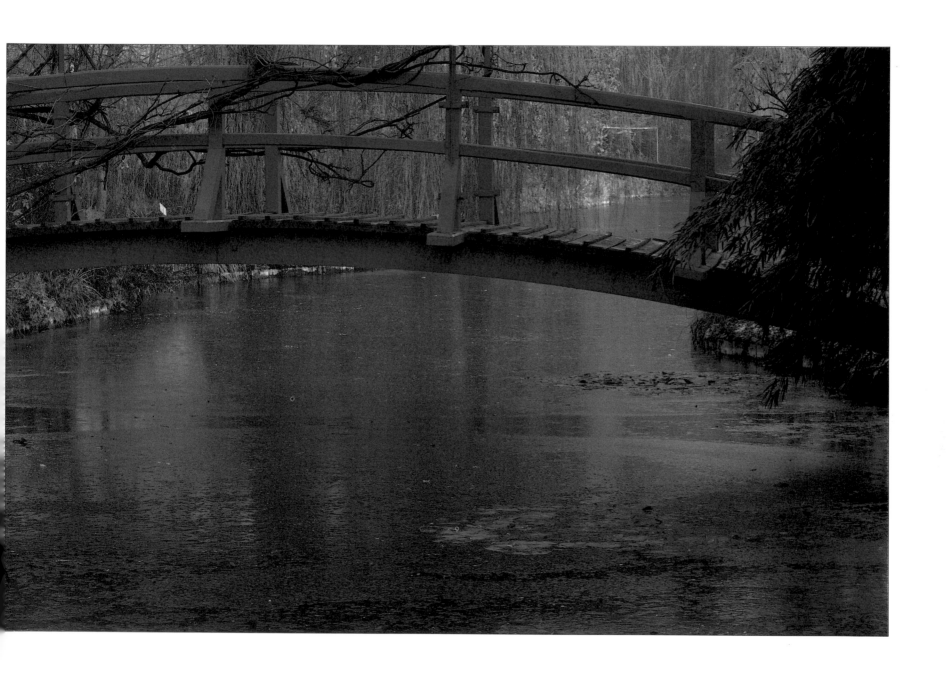

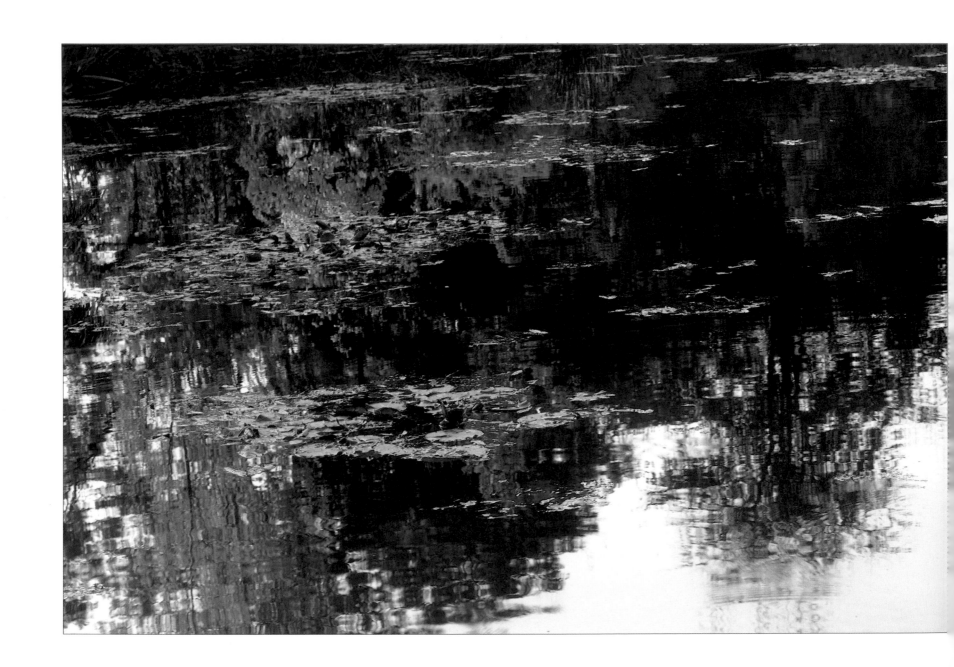

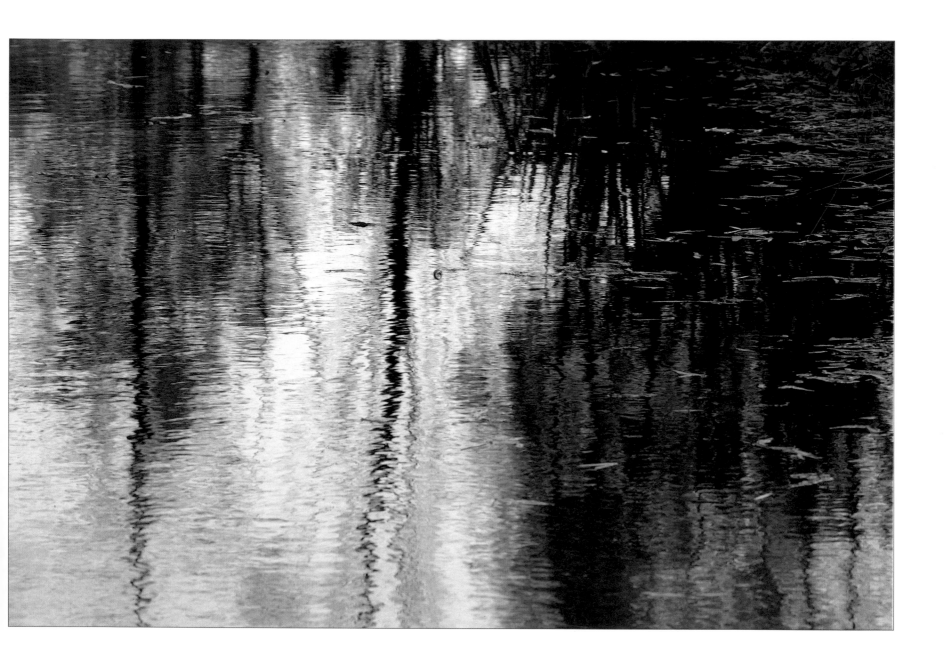

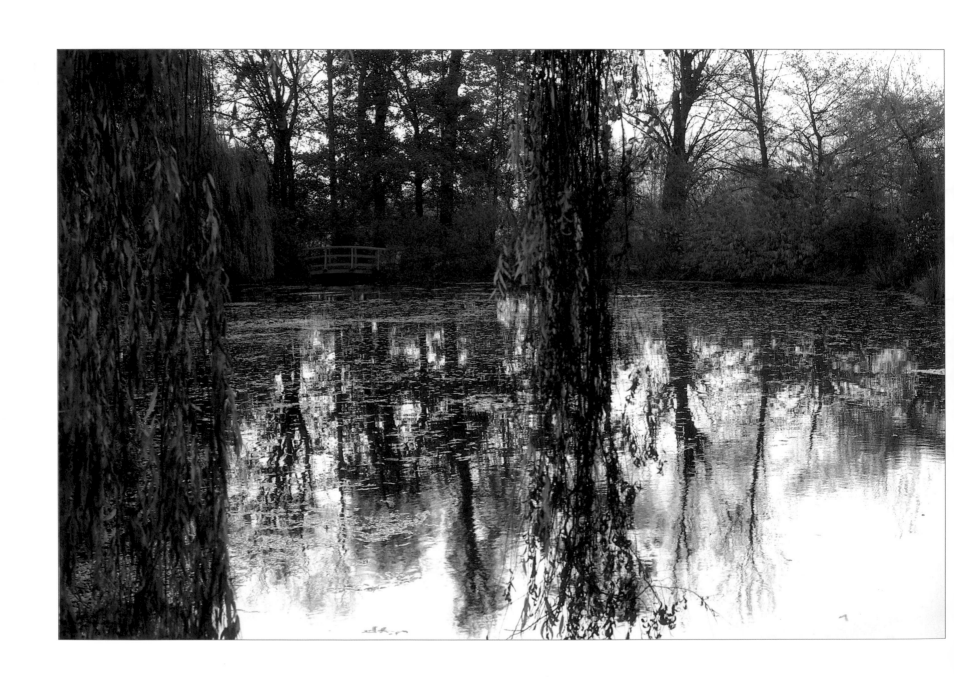

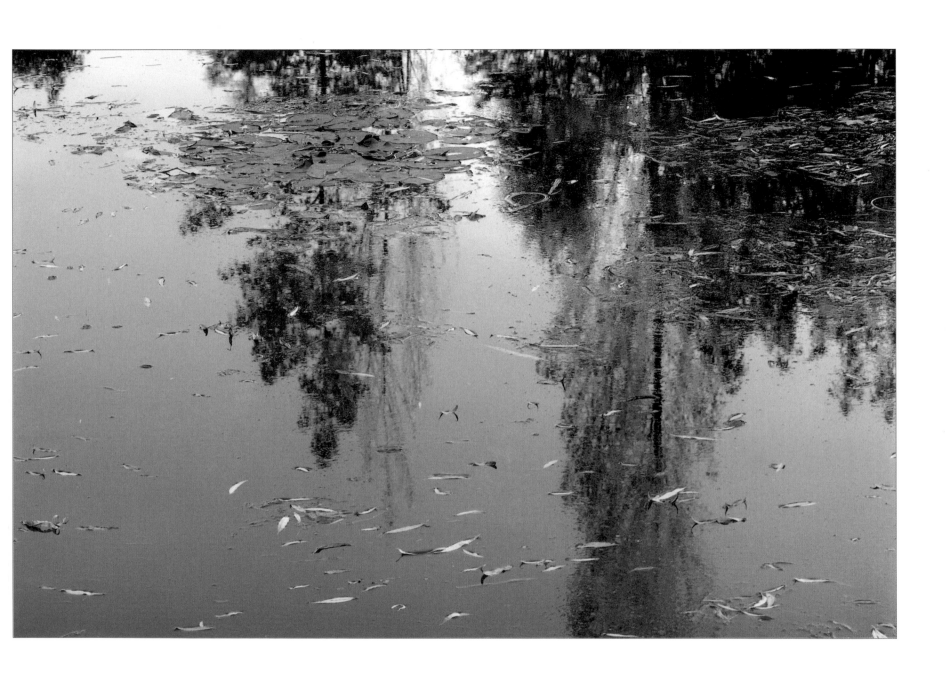

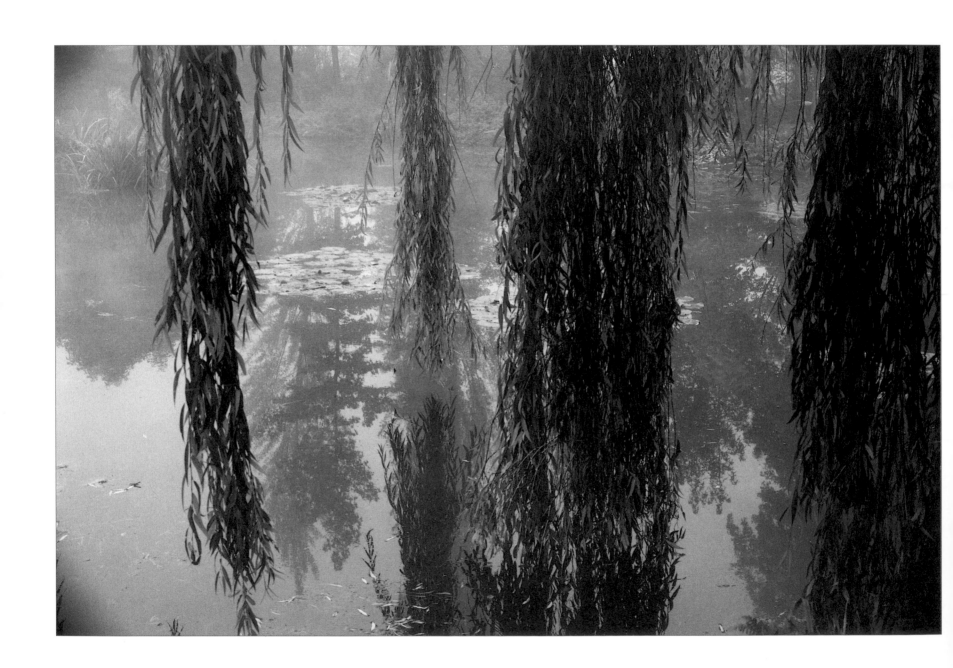

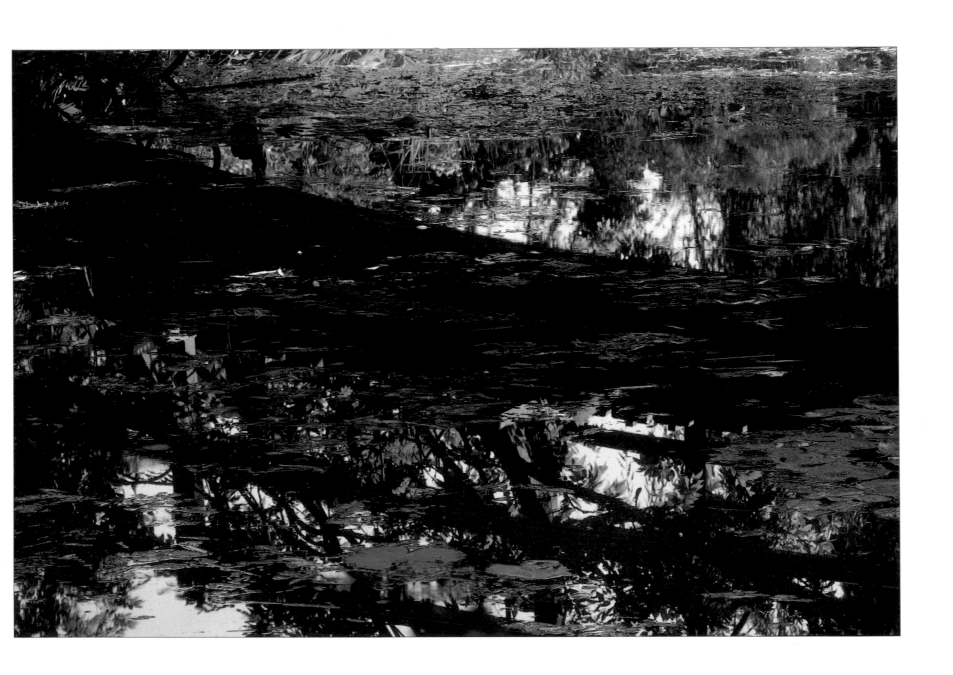

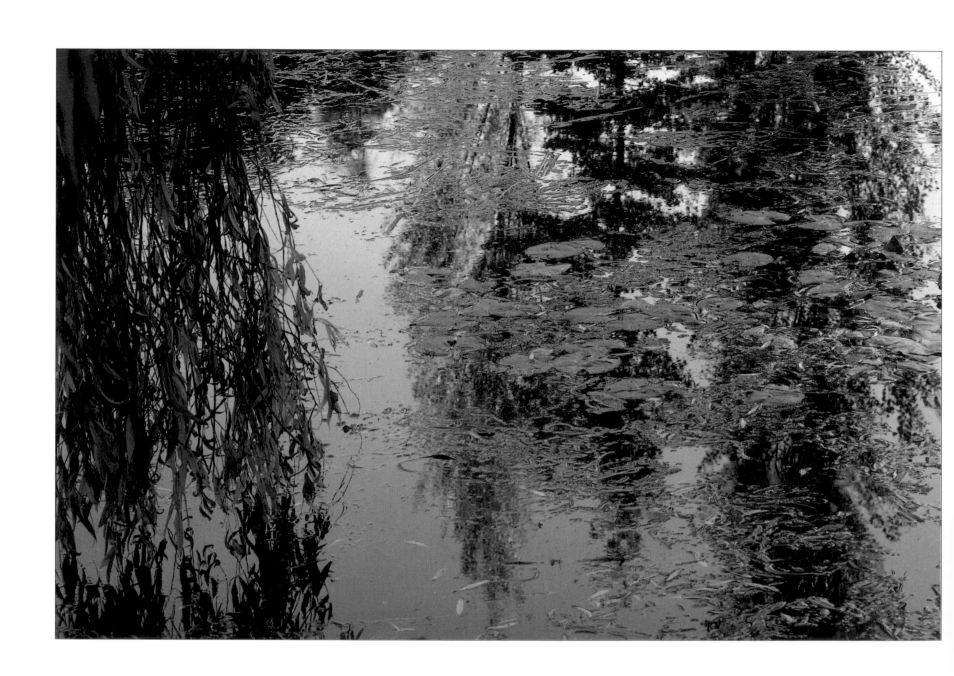

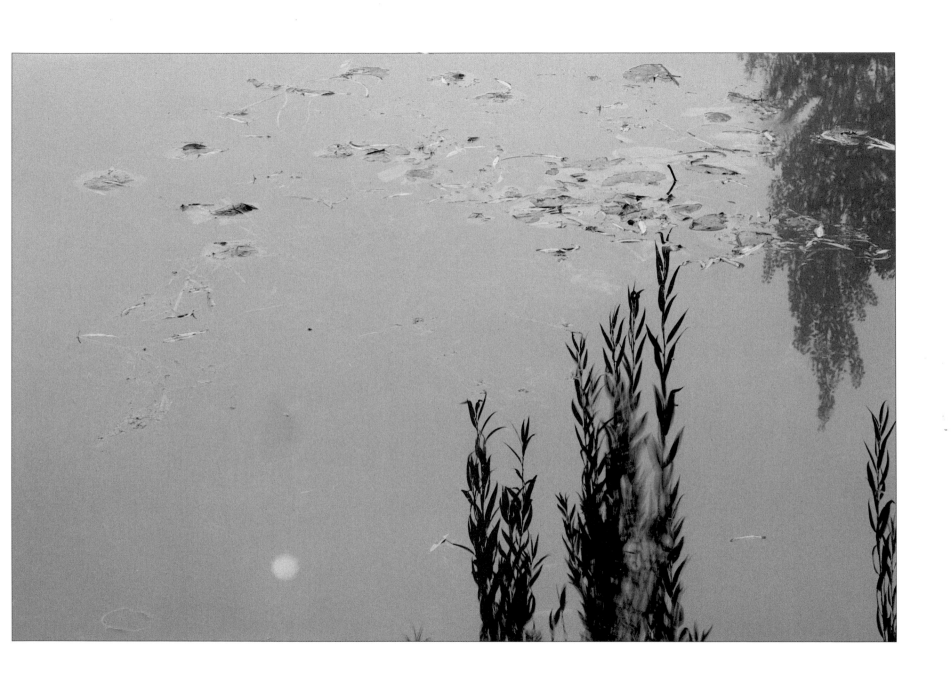

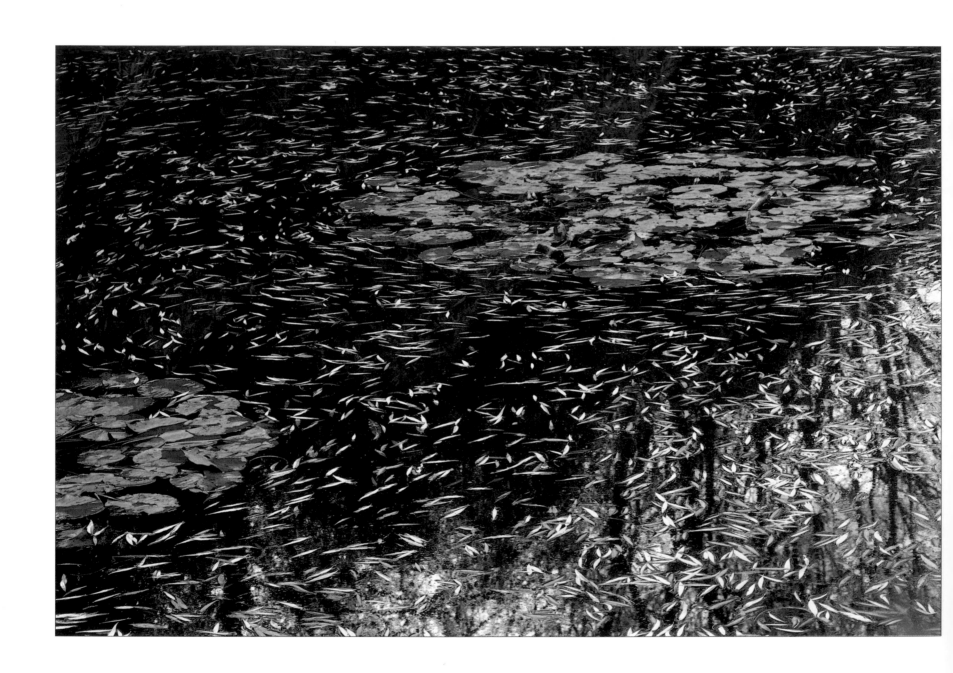

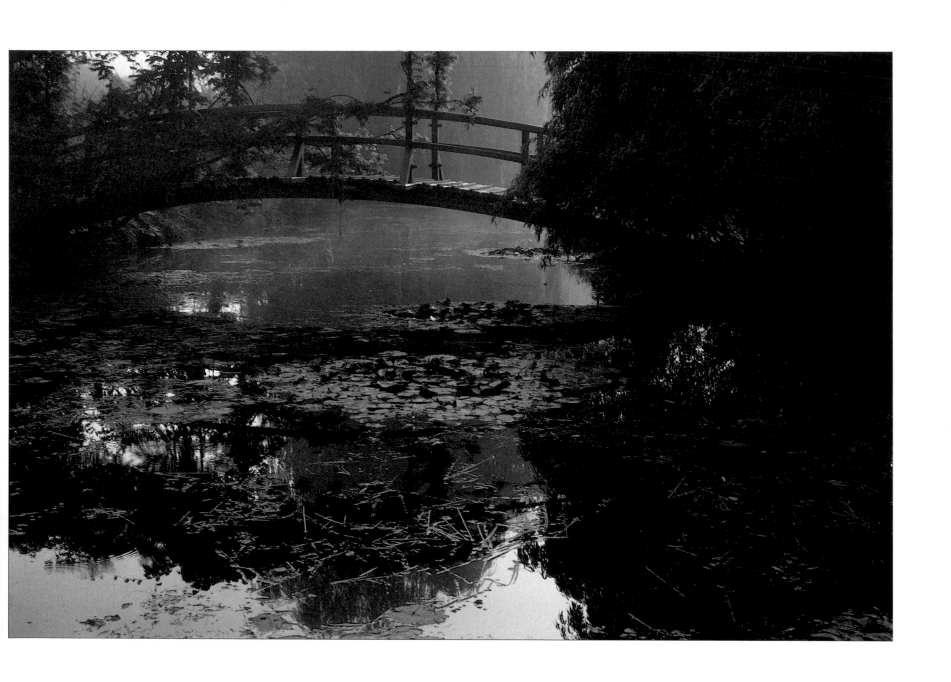

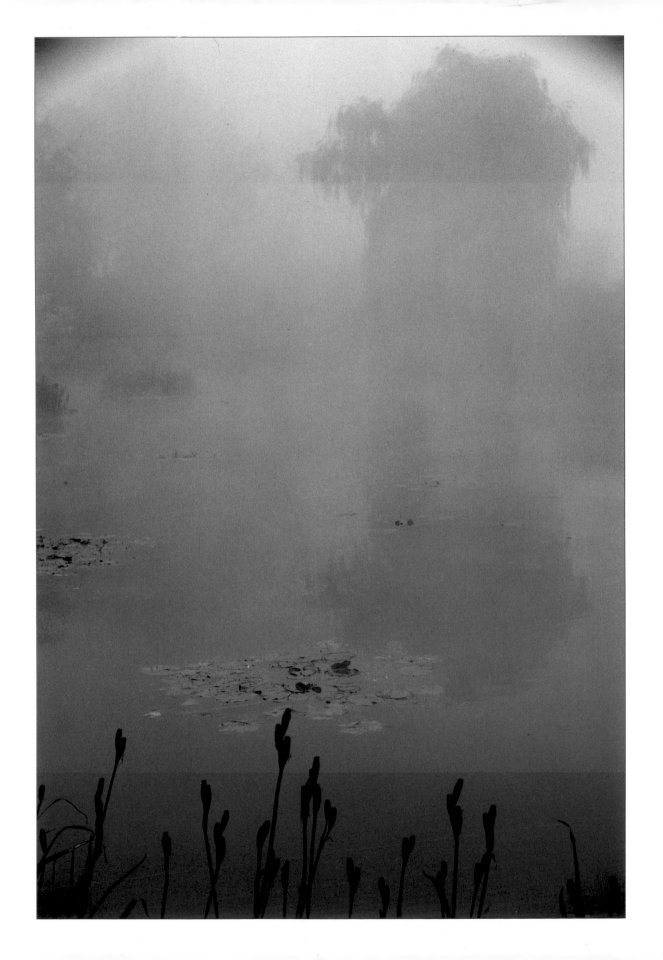

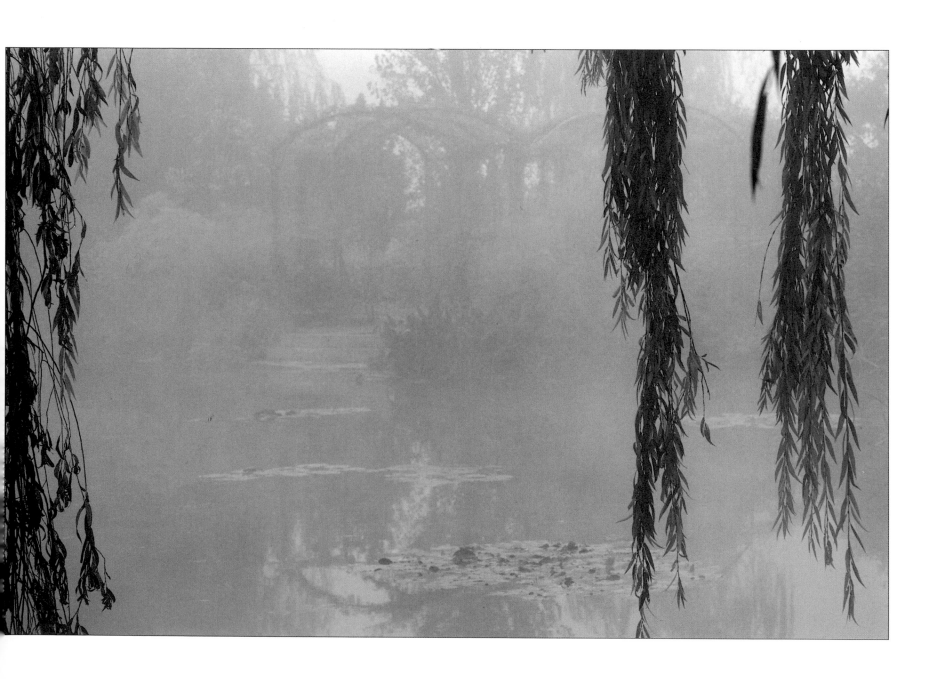

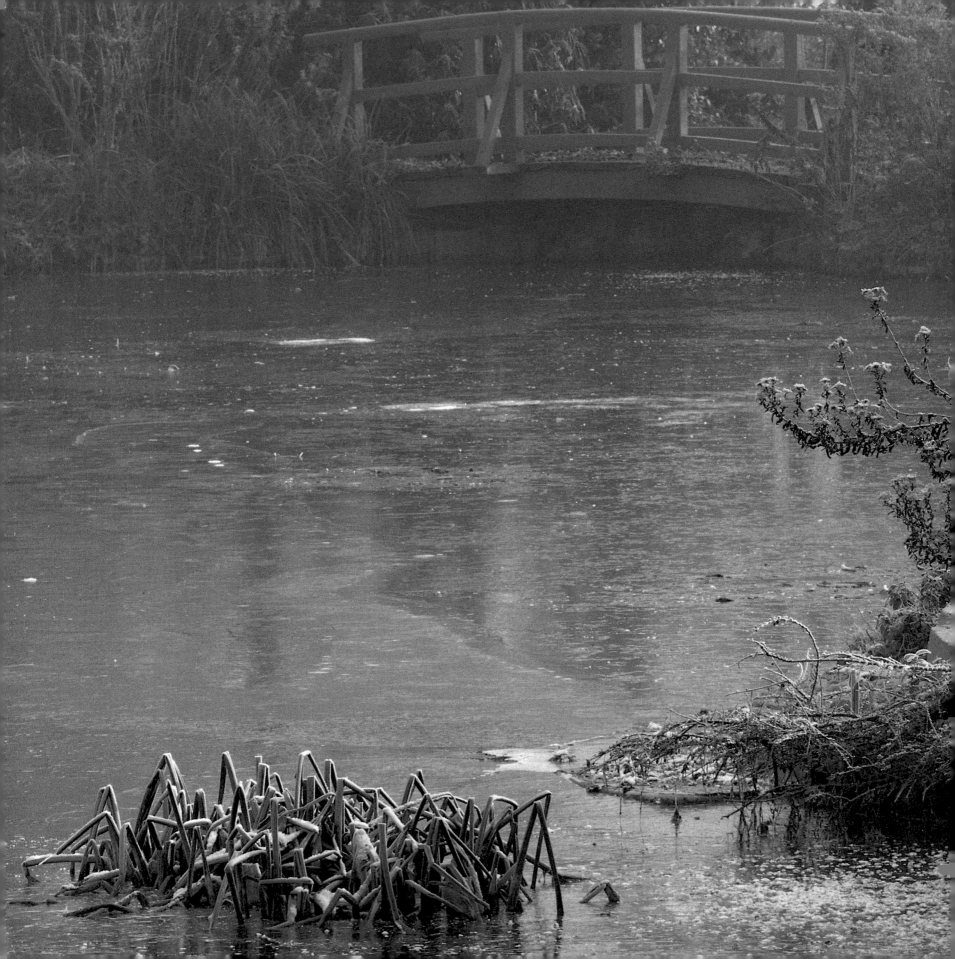

*winter*

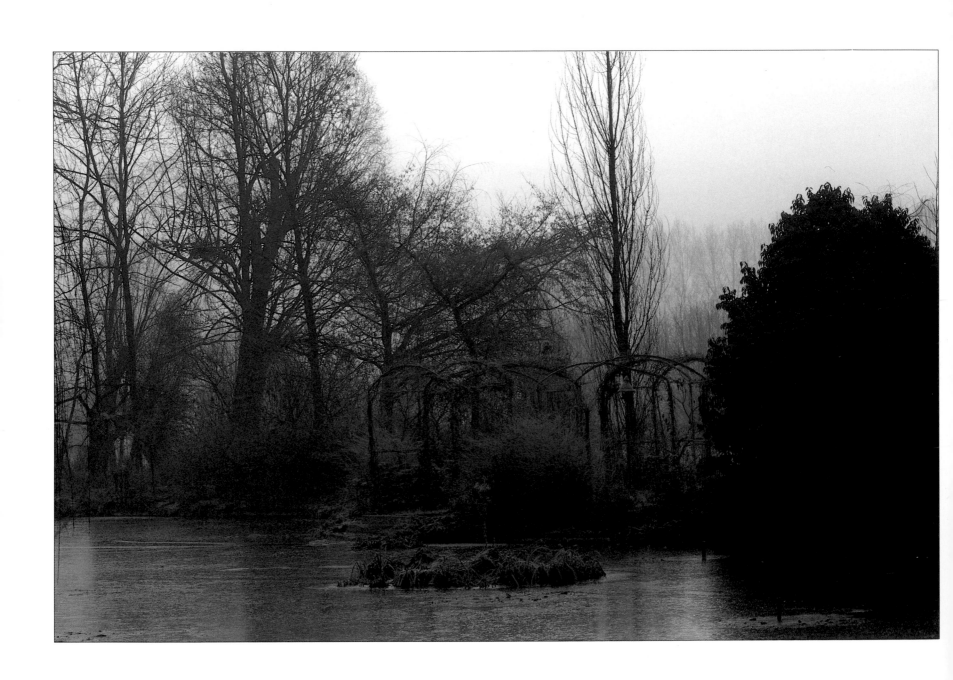

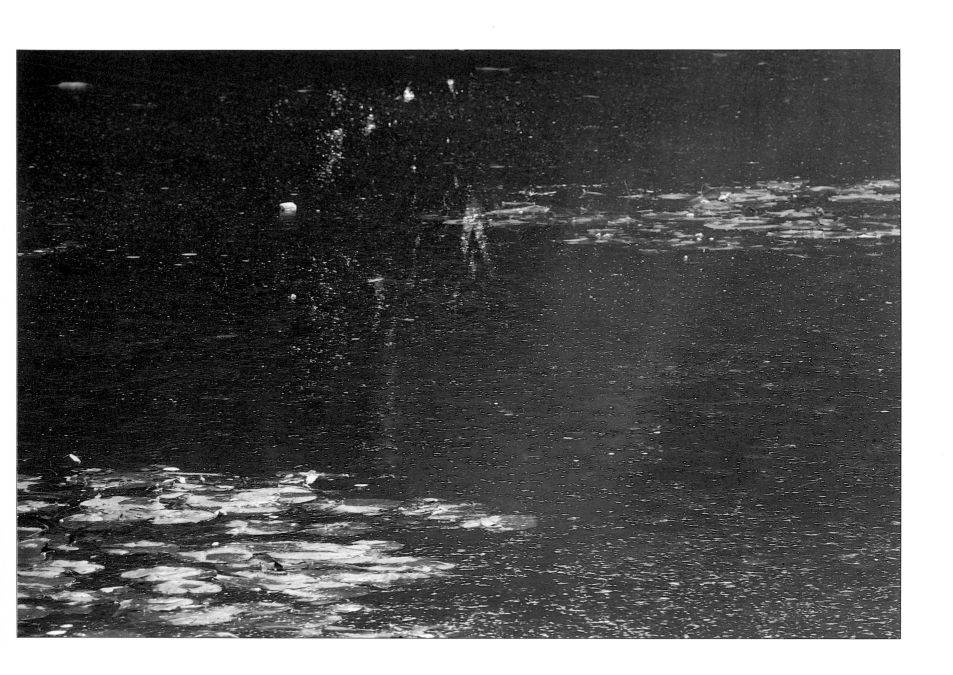

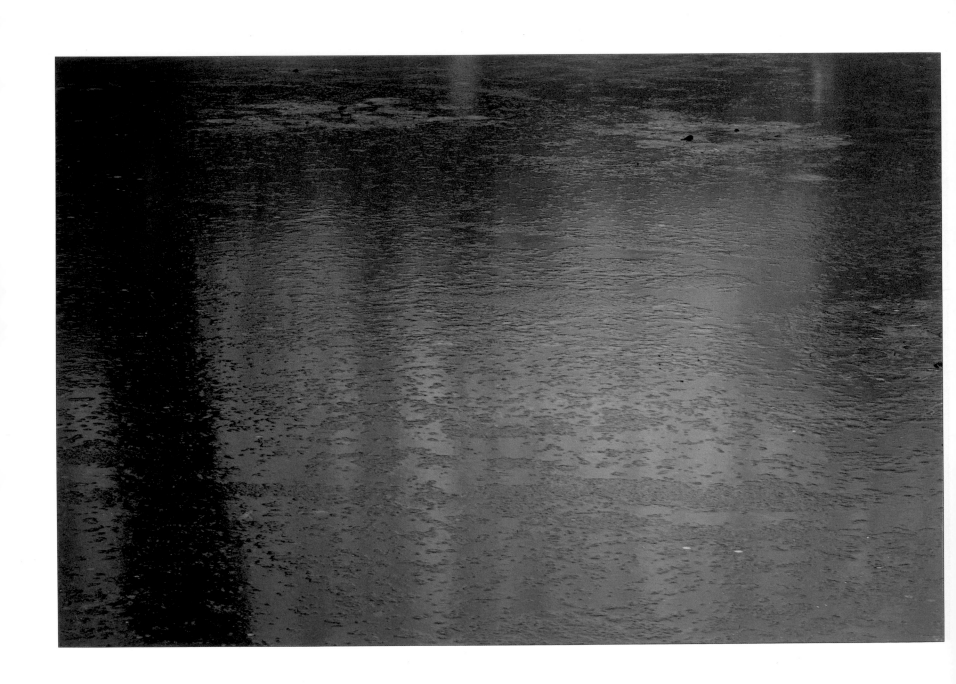

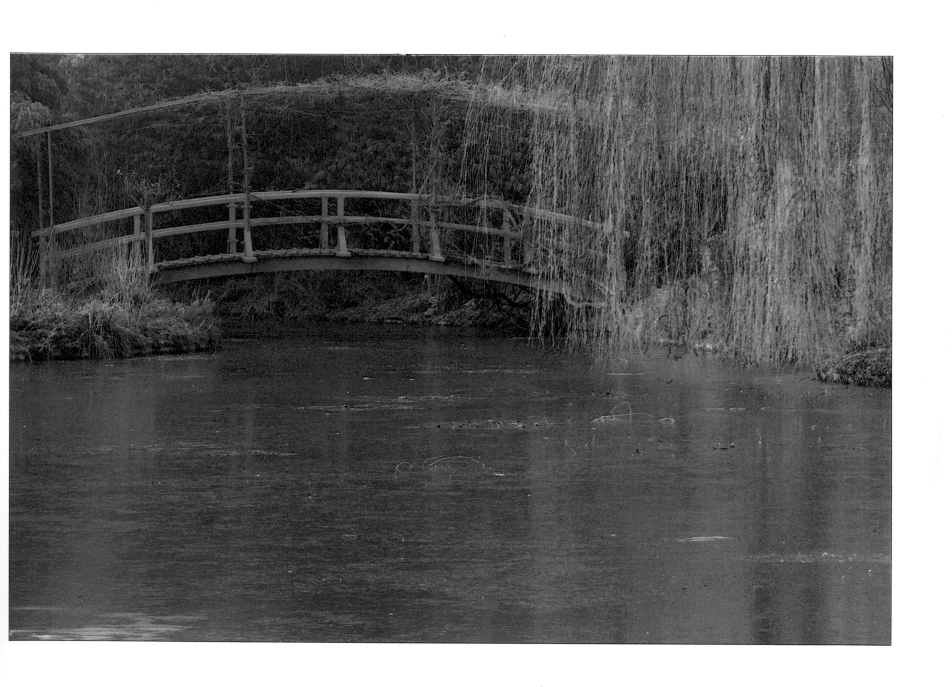

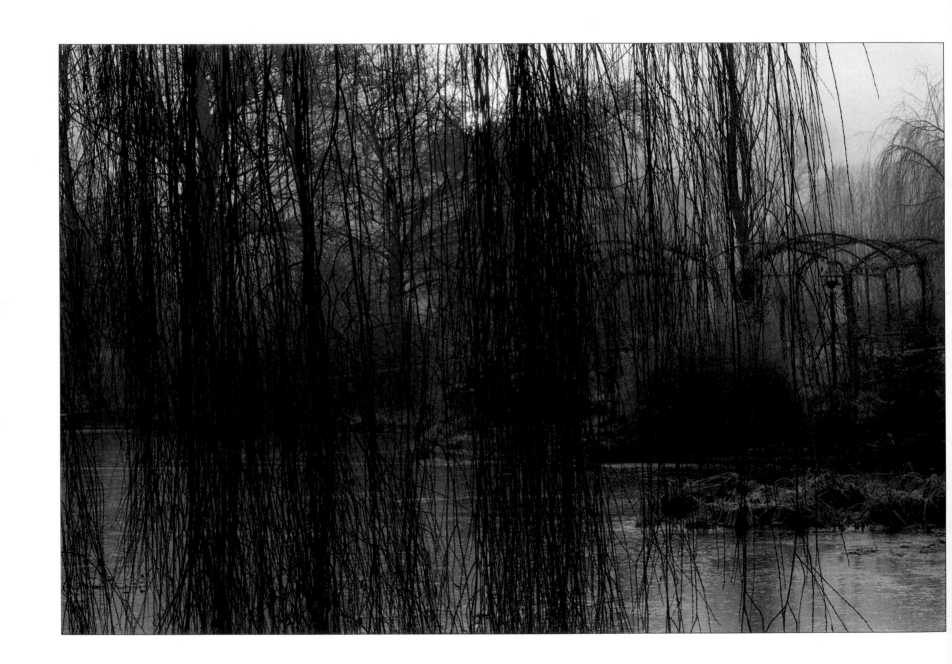

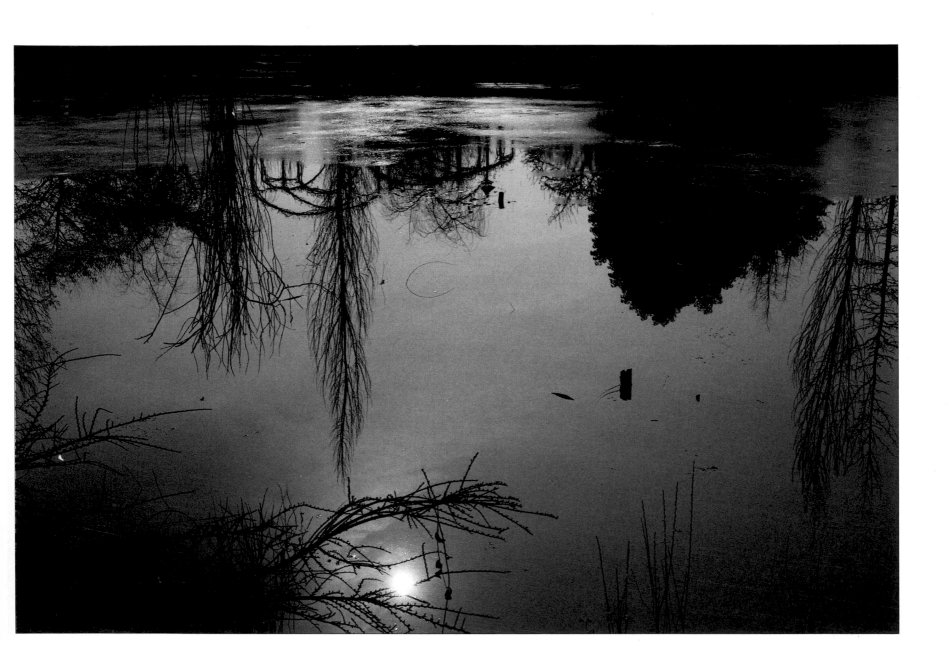

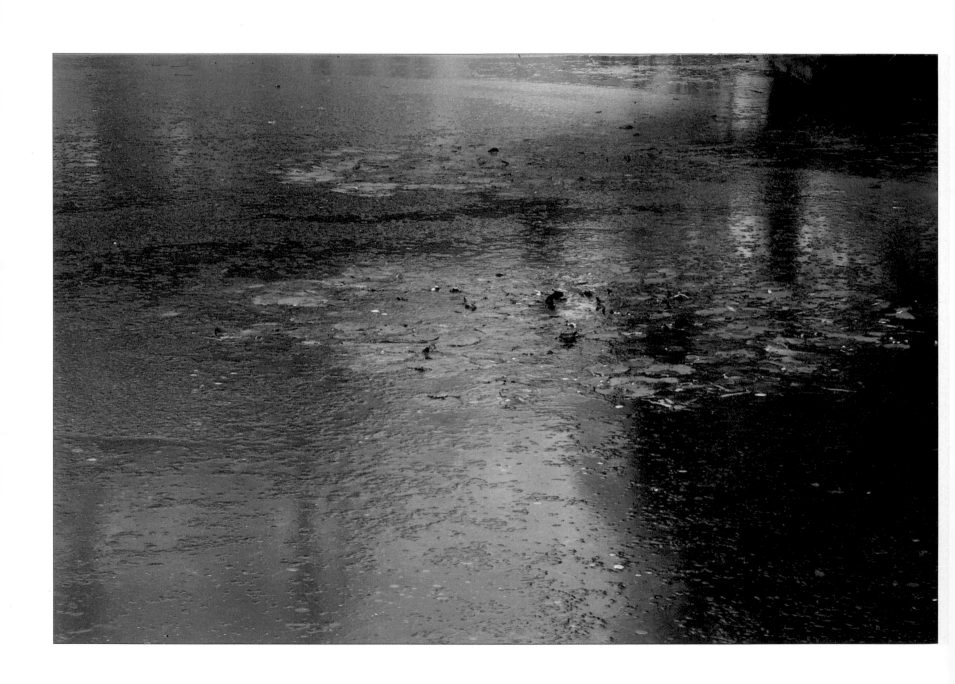

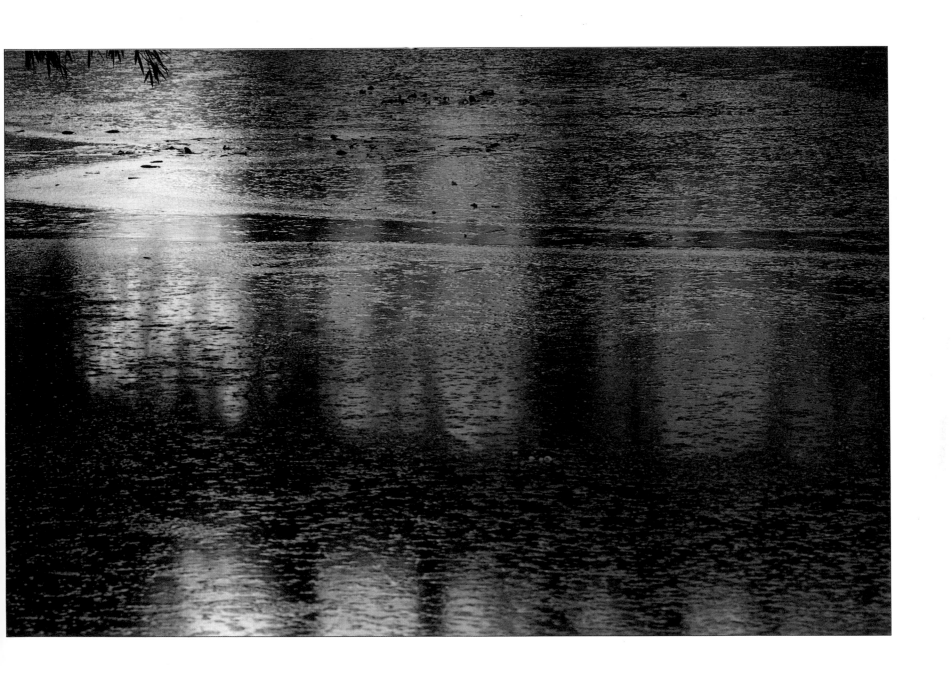

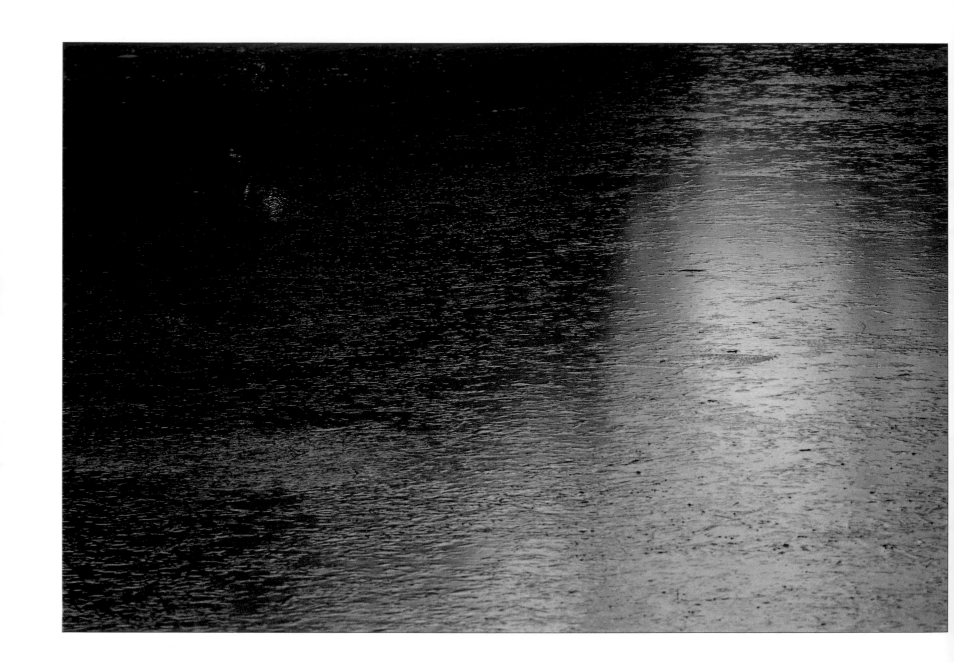

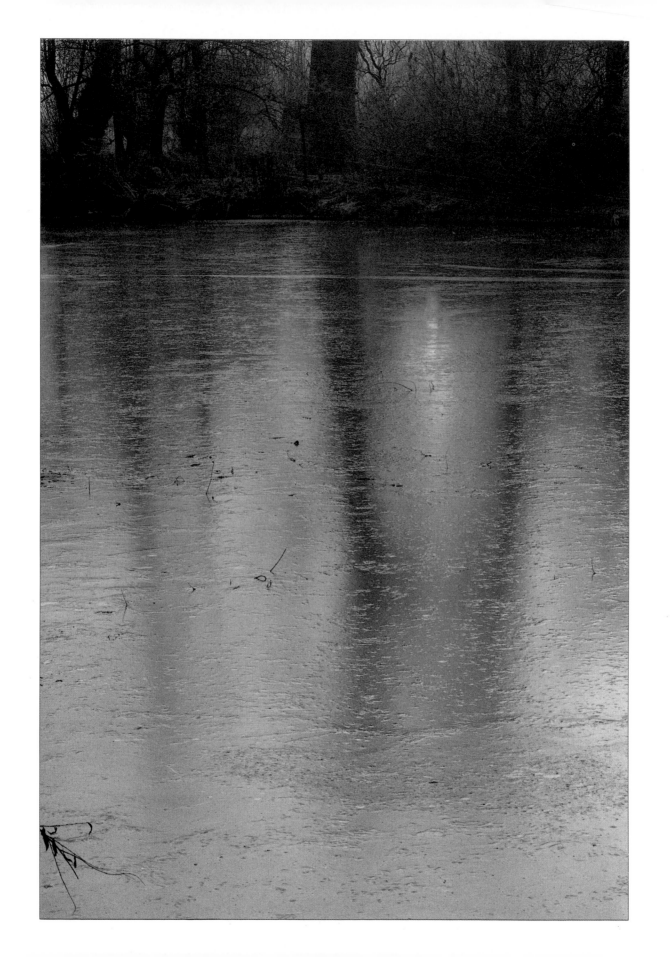

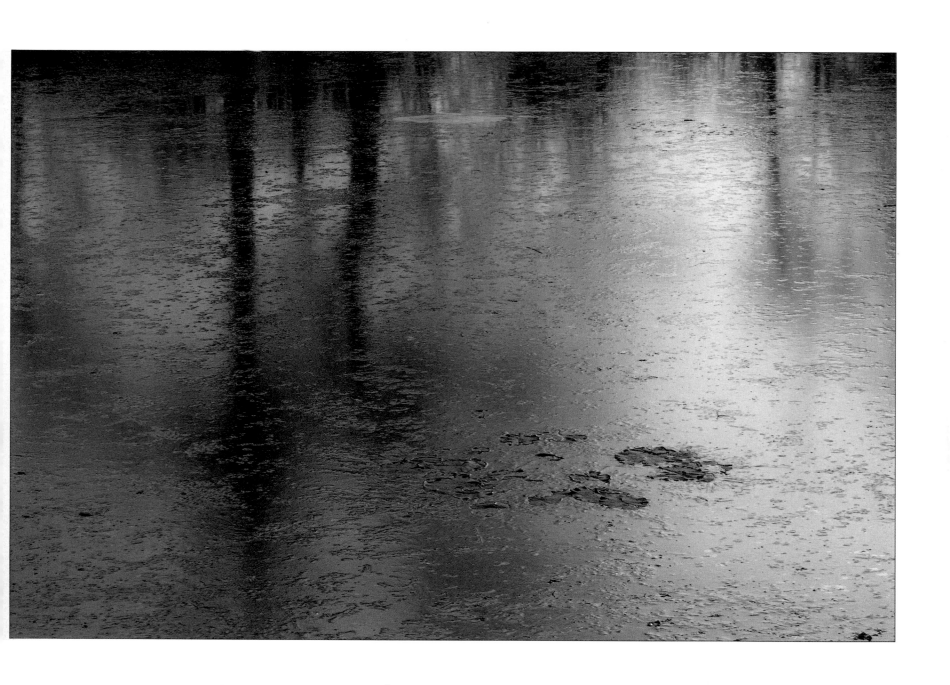

**26–27** In Monet's earth garden, the "Clos normand," behind a specific flower (here it is a purple tulip), I have often photographed colorful spectacles—Monet's palette when he became the gardener. The red tulip stands out on a yellow background of indistinct flowers (that one would not see better if one stood closer) above the blue-violet forget-me-nots, above yellow flowers at the bottom of the picture that echo the yellow further out on the upper part. One can measure here the richness of Monet's palette in the Giverny gardens.

**28** Claude Monet's house: the staircase leading to the kitchen

**29** The garden at the end of a path

**30** Mixed flowers: digitalis, poppies, gaillardia

**31** In another setting, another tulip arrangement

**32** Poppies and hemerocallis

**33** Oriental poppies

**34-35** Irises

**36** The colors used freely in the earth garden, "the delicious, already made palette where the harmonious tonalities are prepared," evoked by Marcel Proust.

**37** By the water lily pond, blue-violet wisteria and rhododendrons. The wisteria, with its huge base was planted by Claude Monet.

**38** On the Japanese bridge, blue-violet wisteria and delicate leaves

**39** On the Japanese bridge: blue-violet wisteria in bloom; white wisteria blossoms later

**40** Water lilies

**41** Water lilies among the reflection of the great willow whose foliage has a yellow color. This photograph could be compared with the "Nymphéas" of the Folkwang Museum in Essen (around 1916) and also with the "Nymphéas" from the Orsay Museum (1917).

**42** Water lilies

**43** Water and reflection: water vegetation among the colors of the earth vegetation: a reflection of azaleas and rhododendrons

**44** Pink water lilies on black water

**45** Water lilies. The black mass is the reflection of the Japanese bridge outlined.

**46** Reflection of earth flowers dimly lit; water vegetation in bright light

**47** Reflection of trees on the water lily pond: their leaves have not yet grown back.

**48** Water lily pond. The arched trellis for the climbing roses is to the right.

**49** A corner of the water lily pond, all the greens from spring and the sky reflecting in it

**50–51** Bamboo, water lilies. The bamboo garden is next to the Japanese bridge. Claude Monet, the gardener, was probably inspired by Japanese art.

**52** Poppy seedpod

**53** Delphiniums. Like the sun seen from behind, the flower called the sunflower has a very civilized shape, very different from the one grown for its seeds and oil. When I take pictures, I do not try to imitate paintings. If I am indebted to anyone, it is more to Max Ernst than to Monet.

**54** Lumps of flowers, mainly poppies

**55** Hemerocallis

**56** Delphiniums and dancing colors

**57** Rudbeckia

**58** Gladiolus

**59** A simple rose

**60** At night, when children go to sleep, water lilies close themselves and go to sleep under the water. They come back to the water surface the following morning.

**61** Leaves of water lilies on black background

**62** Early in the morning: awakening

**63** One wakes up little by little.

**64** What attracted me is the bent shape of a stem out of the water that connects two strong points of the picture.

**65** A begonia flower fell into the pond. It is floating.

**66** Water lilies: shade and light

**67** Under the Japanese bridge

**68** Water lilies: vegetation imitates abstract painting

**69** Early in the morning, in monochrome, these water lilies remind us of Chinese paintings. As far as art is concerned, water lilies are beings with a wide knowledge and it is most interesting to have a chat with them.

**70** Water lilies: willow and its reflection